CONTENTS

PORTRAIT OF AN ARTIST
ALWYN CRAWSHAW

▲ Alwyn Crawshaw in his studio.

Successful painter, author and teacher, Alwyn Crawshaw was born at Mirfield, Yorkshire and studied at Hastings School of Art. He now lives in Dawlish, Devon with his wife June, where they have their own gallery.

Alwyn is a Fellow of the Royal Society of Arts, and a member of the British Watercolour Society and the Society of Equestrian Artists. He is also President of the National Acrylic Painters Association and is listed in the current edition of *Who's Who in Art*. As well as painting in watercolour, Alwyn also works in oil, acrylic and occasionally pastel. He chooses to paint landscapes, seascapes, buildings and anything else that inspires him. Heavy working horses and elm trees are frequently featured in his paintings and may be considered the artist's trademark.

This book is one of eight titles written by Alwyn Crawshaw for the HarperCollins *Learn to Paint* series. Alwyn's other books for HarperCollins include: *The Artist at Work* (an autobiography of his painting career), *Sketching with Alwyn Crawshaw*, *The Half-Hour Painter*, *Alwyn Crawshaw's Watercolour Painting Course*, *Alwyn Crawshaw's Oil Painting Course* and *Alwyn Crawshaw's Acrylic Painting Course*.

To date Alwyn has made five television series: *A Brush with Art, Crawshaw Paints on Holiday,*

4

COLLINS • Learn to paint

Watercolours

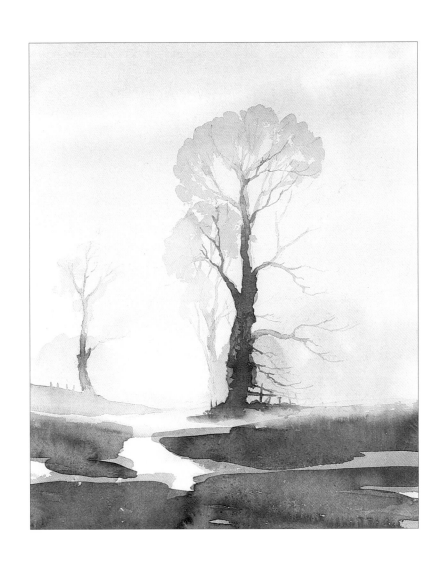

ALWYN CRAWSHAW

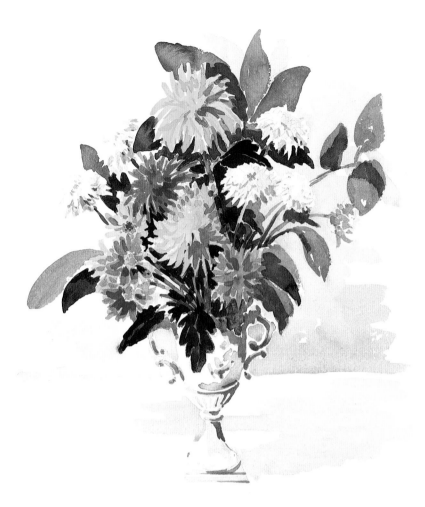

This edition produced for The Book People Ltd, Hall Wood Avenue,
Haydock, St. Helens, WA11 9UL

First published in 1979 by
William Collins Sons & Co Ltd, London
Reprinted 7 times
New edition 1986, reprinted 7 times

Reprinted 7 times by HarperCollins*Publishers*

New edition published in 1995 by
HarperCollins*Publishers*
77-85 Fulham Palace Road
Hammersmith
London W6 8JB

The HarperCollins website address is www.**fire**and**water**.com

Collins is a registered trademark of HarperCollins Publishers Limited.

00 02 04 05 03 01
8 10 12 14 15 13 11 9 7

© Alwyn Crawshaw 1979, 1986, 1995

Alwyn Crawshaw asserts the moral right to be identified
as the author of this work.

A catalogue record for this book is available from the British Library

Editor: Flicka Lister
Design Manager: Caroline Hill
Design: Flicka Lister and Susan Howe
Photography by Michael Petts and Nigel Cheffers-Heard

ISBN 0 00 761410 1

Printed and bound by Printing Express, Hong Kong

FRONT COVER: River Otter, Ottery St Mary, Devon
(detail, 37 × 45 cm/14½ × 17¾ in)

Crawshaw Paints Oils,
Crawshaw's Watercolour Studio
and *Crawshaw Paints Acrylics,*
and for each of these he has
written a book of the same title to
accompany the series.

Alwyn has been a guest on
local and national radio
programmes and has appeared
on various television programmes.
In addition, his television
programmes have been shown in
the USA. He has made several
successful videos on painting and
in 1991 was listed as one of the
top ten artist video teachers in
America. Alwyn is also a regular
contributor to the *Leisure Painter*
magazine. Alwyn organizes his
own successful and very popular
painting courses and holidays.
He has also co-founded the
Society of Amateur Artists, of
which he is President.

Fine art prints of Alwyn's well-
known paintings are in demand
worldwide. His paintings are sold
in British and overseas galleries
and can be found in private
collections throughout the

world. Painted mainly from
nature and still life, Alwyn's work
has been favourably reviewed by
the critics. The *Telegraph
Weekend Magazine* reported him
to be 'a landscape painter of
considerable expertise' and the
Artists and Illustrators magazine
described him as 'outspoken
about the importance of
maintaining traditional values in
the teaching of art'.

▲ St Clement's Bay, Jersey
Whatman 200 lb Rough
38 × 55 cm (15 × 22 in)

▼ They said 'Sunny intervals and dry!'
Waterford 300 lb Rough
38 × 50 cm (15 × 20 in)

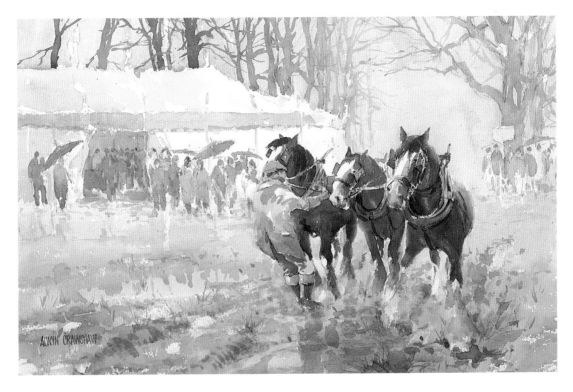

WHY DO ARTISTS PAINT?

Painting is one of man's earliest and most basic forms of expression. Stone Age man drew on his cave walls. Usually, these drawings were of wild animals and hunting scenes. It is difficult to say whether these were created by the artist to be instructional – a means of showing children what a certain animal looked like, for instance – or as a form of cave decoration, or whether they were just a relaxing pastime to release creative feelings.

Whatever the reason, these early artists must have been a creative and dedicated people; there was no local art shop to provide them with their materials and no electric light to help on dark days. All this started over twenty-five thousand years ago and painting is still with us today.

Naturally, over this long period, painting has become very sophisticated. Artist's materials have also undergone vast changes and the tremendous range now available, plus the variety of methods that are with us today, can make painting very frightening for the beginner: people can be put off by not knowing where or how to start.

HAVE YOU TRIED?

One of the most frequent statements made to me is: 'I wish I could paint'. My reply is always, 'Have you tried?' and invariably

▲ *If you like painting outside, Alwyn will help you experiment with watercolour styles and techniques.*

the answer comes back: 'No, I haven't. I wouldn't know how to start'. How can anyone say they can't paint when they have never tried! Have you ever asked anyone if they can drive a car? If the answer is no, it will usually be followed by: ' I haven't tried yet but I am going to have lessons'. There seems to be a veil of mystery around painting but not around driving a car! So let me clear up some of the mysteries surrounding painting, from a beginner's point of view.

First of all, you may feel daunted by the sheer volume of work that has been created over the past thousands of years, the hundreds of styles and techniques used, from painting on ceilings to painting miniatures. There is Prehistoric

painting, Greek painting, Egyptian painting, Byzantine painting, Chinese painting, Gothic art, Florentine painting, Impressionism, Surrealism, Abstract art, Cubism, and so on.

Of course, all these styles can make the mind boggle and to unravel all of them and understand the differences could take a lifetime. So what are we to do and where do we start?

The simplest answer is to forget all you have picked up in the past and start from the smallest beginnings like Stone Age man.

FEELING CREATIVE

Today, most people who want to paint have one thing in common – a creative instinct. Unfortunately, many people don't realise this until later on in life, when something stirs within them or circumstances set them on the road to painting.

For some people painting becomes a fascinating hobby. For others, it becomes their only way of expressing their innermost thoughts and leads to a means of communicating with other people. For anyone who happens to be house-bound, painting can have a real therapeutic function.

Through painting, people meet and make friends either by joining art societies (most towns have one) or by progressing and selling their works at local art shows, in local shops and so on.

I think, above all, painting can be a creative way of getting involved, forgetting your immediate troubles, great or

▶ *Watercolour is also an ideal medium if you prefer painting at home or in a studio.*

small, and finishing up with a work of art that you can share with others and enjoy for the rest of your life.

FIRST STEPS

By now, as a reader of this book, you have taken your first big step. If you are a beginner, this means that you are curious about painting and want to find out all about it. You have also selected a medium with which to start: watercolour. If you already paint and are reading this book in order to learn about the medium of watercolour, then probably you are looking for exciting new ways to express your creative skills.

So, as I said earlier, let's start right at the beginning. But don't rush out to find the nearest cave!

I will take you through this book stage by stage, working very simply to start with and progressing to a more mature form of painting.

If you have some watercolours, the most difficult thing to do at the moment will be to read on – your desire to try out the paint will have been stimulated by looking through the book and seeing the colour pages and different methods of working. If this is the case, I thoroughly recommend one thing first – relax and read on before you start. Then, when you do begin the lessons and exercises, enjoy them. If you find some parts difficult, don't become obsessed with the problem. Go a stage further and then come back. Seeing problems with a fresh eye often makes them easier to solve.

WHY USE WATERCOLOURS?

I am constantly asked why I paint in more than one medium. The reasons are varied. An artist sometimes uses a medium because he has been commissioned to do so or because he likes one medium more than another, but more important is the fact that each medium has its own mystique and, of course, a particular quality. There is also the restraint of size. For instance, a sheet of watercolour paper isn't made large enough for a 76 × 152 cm (30 × 60 in) painting and neither is pastel paper, so the medium can determine the size of the painting. Finally, the subject matter has to be considered. When I am out looking for possible subjects, I see one as a subject for an acrylic painting, another as a perfect watercolour, and so on.

Whatever your reason for choosing watercolour, even if it's the obvious one – you like it! – you have made the choice and we will work together over the next fifty-six pages, from simple beginnings to more serious exercises later.

First, a word of caution. Because your earliest recollection of painting – probably when you were at infant school – is associated with the use of water-based paint (poster paint, powder colour or watercolour) you may have the impression that it is easy. Well, of course, to enjoy painting and get

favourable results is relatively easy. However, to get the desired results through deliberate control of watercolour needs plenty of practice and patience, but the more you learn, the more you will enjoy using watercolour.

WHAT IS WATERCOLOUR?

Watercolour is so called because the adhesive that sticks the pigment powder to the paper is soluble in water. The paint is a finely ground mixture of pigment, gum arabic (the water-soluble gum of the acacia tree), glycerine (to keep the colours moist) and glucose (to make the colours flow freely).

When water is loaded on to a brush and added to the paint on

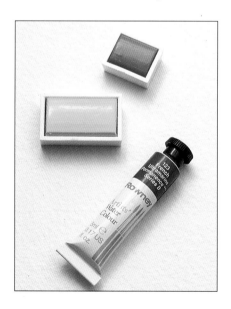

▲ *Half pan, whole pan and tube of watercolour paint.*

the palette, the paint becomes a coloured, transparent liquid. When this is applied to the white surface of the paper, the paper shows through and the paint assumes a transparent luminosity unequalled by any other medium. You buy the colours either in a half pan, a whole pan or a tube (see below). I will explain more about this in the equipment section.

One great advantage of watercolour is that it requires no complicated equipment. For painting outdoors, for instance, your basic essentials are a pencil, a box of paints, a brush, paper and water. You will find that the paint dries within minutes of its application to the paper as the water evaporates, leaving the dry colour on the surface. This process can be seen when working. While the paint is shiny on the paper, it is still wet and you can move it about or add more colour with the brush, but as soon as the shine goes off the paper (the paint is now in an advanced drying stage) you must leave it alone and let it dry. If you try to work more paint into it, you will get nasty streaks and blotches.

Because the paint dries quickly – especially if you are under a hot sun – watercolour painting does not favour faint hearts. If you think you are in that category, don't worry. You will gain confidence as you read and work through the book.

Before you start a painting, you need to have a plan of campaign in your mind. Naturally, as you progress, this will become second nature to you. When I was at art school I was taught to look and observe and, ever since, I have always looked at the sky as if it were a painting and considered how it had been done – in which medium, with which brush, which colour was used first, and so on. I see things as colours, and techniques of painting.

PAINT CONTROL

Nevertheless, you will have to accept the fact that not every watercolour painting is a success – not to you, the artist, that is.

You will find that you paint a beautiful picture, everyone likes it and it is worthy of being put into an exhibition, but there will be passages of that painting where the watercolour was not completely under your control and it made up its own mind about the final effect. Well, this is an accepted characteristic of watercolour painting – only the artist knows how he made the paint behave or misbehave! But when you paint a good picture with plenty of watercolour effect and it was all under your control, then you will have achieved a small, personal ambition which will no doubt elevate you into that special band of dedicated watercolourists.

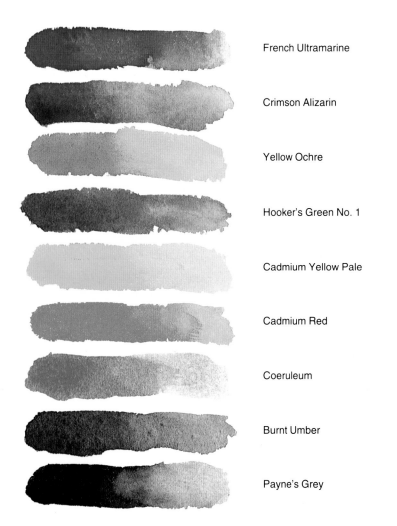

French Ultramarine

Crimson Alizarin

Yellow Ochre

Hooker's Green No. 1

Cadmium Yellow Pale

Cadmium Red

Coeruleum

Burnt Umber

Payne's Grey

▲ *The first six colours illustrated above are the colours that I use for all my paintings. The following three I only use occasionally. All these colours will be referred to throughout this book. Please note that this colour chart is produced within the limitations of printing and is intended as a guide only.*

ADDITIONAL COLOURS AVAILABLE

Naples Yellow	Crimson Lake	Terre Verte (Hue)
Lemon Yellow	Permanent Rose	Cobalt Green
Permanent Yellow	Purple Lake	Brown Pink
Cadmium Yellow	Purple Madder (Alizarin)	Raw Sienna
Aureolin	Permanent Magenta	Burnt Sienna
Chrome Lemon	Cobalt Violet	Light Red
Gamboge (Hue)	Permanent Mauve	Venetian Red
Chrome Yellow	Violet Alizarin	Indian Red
Cadmium Yellow Deep	Prussian Blue	Brown Madder (Alizarin)
Indian Yellow	Indigo	Raw Umber
Chrome Orange (Hue)	Monestial Blue	Vandyke Brown
Cadmium Orange	Cobalt Blue	Warm Sepia
Chrome Orange Deep	Permanent Blue	Permanent Sepia
Vermilion (Hue)	Alizarin Green	Davy's Grey
Permanent Red	Sap Green	Neutral Tint
Rose Doré (Alizarin)	Monestial Green	Ivory Black
Scarlet Alizarin	Olive Green	Lamp Black
Scarlet Lake	Hooker's Green No. 2	Chinese White
Carmine	Viridian	

PAINTING EQUIPMENT

Every professional artist has his or her favourite brushes, colours, and so on. In the end, the choice must be left to you, to make from your personal experience. In the last chapter I gave you a list of the colours that I use. I suggest that you, too, use these as you work through this book because I shall refer to them to describe different colour mixes. You may find that you prefer to drop a couple of colours or change some once you have made some progress – this will be fine and, of course, it also applies to other materials used in the exercises.

▲ *Copies of original Artists' Watercolour Boxes first sold by Thomas and Richard Rowney between 1795 and 1810.*

BUYING COLOURS

To get the best results, you should use the best materials you can afford. The two main distinctions between different watercolour paints are cost and quality. The best quality watercolours are called Artists' quality Watercolours and those a grade lower are called students' watercolours. Daler-Rowney manufacture a student range under the Georgian brand name, as well as an Artists' quality range.

Watercolour paints can be bought in a watercolour box, filled with colours, or in separate pans which you can use as refills or to fill an empty box with your own choice of colours. If you use tubes of paint, you have to squeeze the colour on to the palette (the open lid of the box) and use the paint as if you were working from pans.

Colours in tubes are ideal for quickly saturating a brush in strong colour, using less water, but I do not advise beginners to use tubes because it is difficult to control the amount of paint picked up by the brush.

You can buy additional palettes for mixing your colours and you can see these in the picture on page 15 with other materials.

CHOOSING BRUSHES

Now we come to the tools of the trade – the brushes. The best quality watercolour brushes are made from Kolinsky sable. They are hand-made and are the most expensive brushes on the market but they give you perfect control over your brush strokes and, if properly cared for, will last a long time. Also in the fine-quality range of watercolour brushes, but less expensive, are those made with squirrel hair, ox-ear hair and ringcat hair.

Man-made fibres are also used in the manufacture of artists' brushes and are used by professional artists as well as amateurs. They are also less expensive than sable brushes. 'Dalon' is the brand name for an excellent range of man-made fibre brushes.

Remember, brushes are the tools with which you express yourself on paper. It is only your use of the brush that reveals your skill to the onlooker and this

applies to watercolour more than any other medium. One brush stroke can express a field, a lake, the side of a boat, and so on; therefore you must know your brushes and what to expect from them.

BRUSH TYPES

There are two basic types of brush: a round brush and a flat brush. Shown opposite are brushes of different shapes, made from different hairs. Usually, the handles of watercolour brushes are short but where the brush can also be used for oil or acrylic painting the handle may be longer.

The round brush is a general purpose one: both a wash and a thin line can be obtained with this shape. Usually, round brushes are graded from size No. 00 to size No. 12 and some manufacturers make a No. 14 size. This scale can be seen in this picture and the brushes are reproduced actual size.

The flat brush is used mainly for putting washes over large areas or where a broad brush stroke is called for. Naturally, the width of these strokes is determined by the size of the flat brush. Flat brushes and very large brushes, such as the squirrel-hair wash brush, have a name or size of their own.

▶ *A selection of brushes for watercolour painting. All brushes are shown actual size and some brush series have additional sizes to those shown, i.e. 9, 11 and 14.*

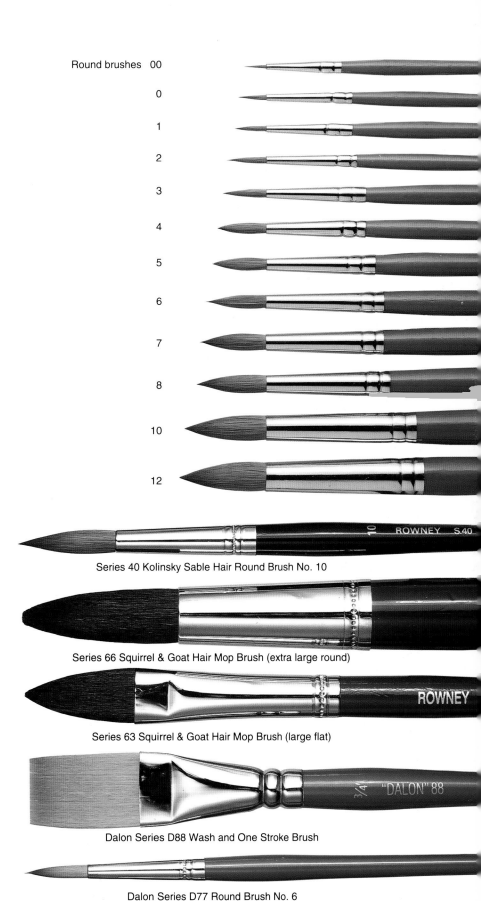

Round brushes 00

0

1

2

3

4

5

6

7

8

10

12

Series 40 Kolinsky Sable Hair Round Brush No. 10

Series 66 Squirrel & Goat Hair Mop Brush (extra large round)

Series 63 Squirrel & Goat Hair Mop Brush (large flat)

Dalon Series D88 Wash and One Stroke Brush

Dalon Series D77 Round Brush No. 6

Dalon Series D99 'Rigger' Brush No. 2

11

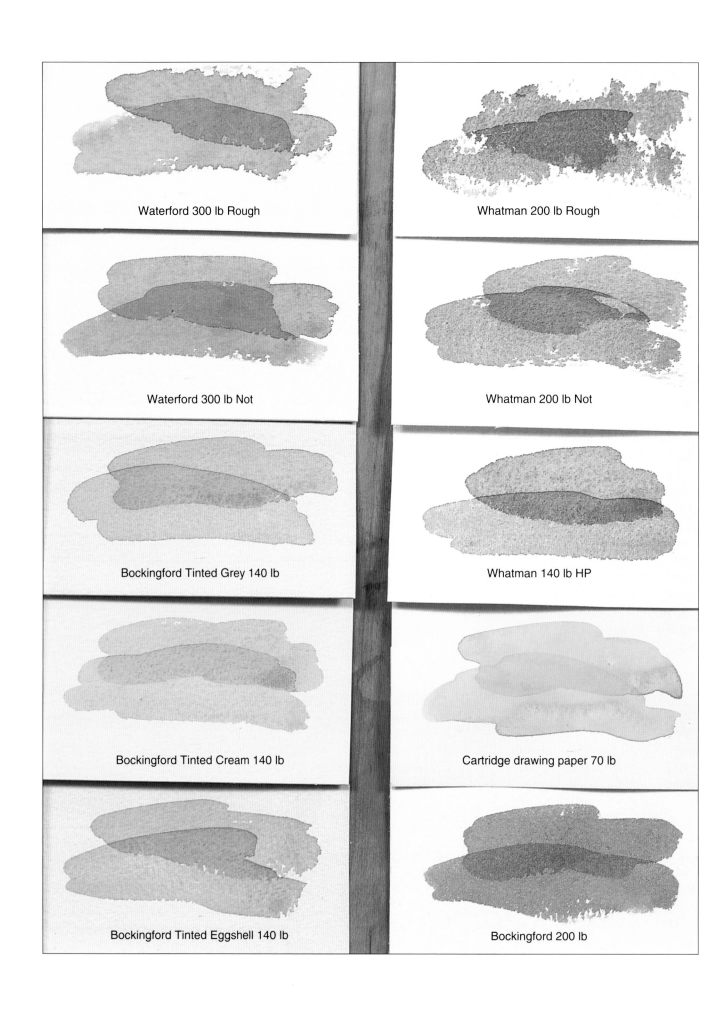

Waterford 300 lb Rough

Whatman 200 lb Rough

Waterford 300 lb Not

Whatman 200 lb Not

Bockingford Tinted Grey 140 lb

Whatman 140 lb HP

Bockingford Tinted Cream 140 lb

Cartridge drawing paper 70 lb

Bockingford Tinted Eggshell 140 lb

Bockingford 200 lb

WHICH PAPER?

You can paint with watercolour on almost any type of paper. You can work on drawing paper, on the inside of a cardboard carton, or even on the back of a roll of wallpaper! Naturally, there are problems in using any old paper. Firstly, if the paper is too absorbent, the liquid will be sucked into the surface like ink on blotting paper and secondly, if the surface is non-absorbent, the paint will run completely out of control. The answer, then, is to use paper that has been specially made for the watercolour artist.

The finest quality papers are made by hand, by craftsmen whose skills have been handed down over the centuries. Up to the beginning of the nineteenth century, even the cheapest wrapping paper was made by hand but then machinery took over a great proportion of the production. Since the best quality watercolour paper is still made by hand it is very expensive. However, in comparison with a ready-stretched canvas of equivalent size, top-quality paper is far cheaper.

SURFACE DETAILS

Watercolour papers have a unique surface texture that is sympathetic to the brush – artists usually refer to it as a 'tooth'. It is this tooth that responds to the brush and helps to create the unique watercolour effect. The paper also has just the right amount of absorbency to hold the liquid colour under manageable control.

There are many types of paper on the market but they all have two things in common: they are

all finished with one of three kinds of surface texture and they are all graded by weight (this tells us the thickness of the paper). The surfaces are: Rough, Not (called Cold Pressed in the USA) and Hot Pressed (HP).

Paper with a Rough surface has a very pronounced texture (tooth) and is usually used for large paintings where bold, vigorous brush work is required. The Not surface has less tooth and this is the one most commonly used by artists. It is also ideal for the beginner. The Hot Pressed surface is very smooth, with very little tooth. Before you try this paper you will need to know how to handle your watercolour: if you use the paint very wet, it can easily run, concerned only for its own destination and your downfall!

There are two other papers that you can work on which I use a lot. These are Bockingford watercolour paper, which only has one surface (very much like the Not surface) and cartridge drawing paper, which only has a smooth surface.

Usually, you buy watercolour paper in an Imperial size sheet

▶ *To stretch paper, cut a sheet of paper slightly smaller than your drawing board. Submerge it in water or hold it under a running tap and completely soak both sides. Hold it up by one end, let the surface water drain off, then lay it on the drawing board. Use a roll of brown gummed paper to stick the four sides down, allowing the gummed paper to fall half over the paper and half over the board. Leave it to dry naturally overnight and by morning it will be as tight as a drum and as flat as a pancake, and will stay flat while you work. The finished result is shown here.*

measuring approximately 76 × 56 cm (30 × 22 in) but hand-made paper sizes can vary by a few inches. You can also buy paper in pads of various sizes.

Paper tends to cockle when you put wet paint on it and the thinner the paper the more it will cockle. In the picture below I show how to get over this problem by stretching the paper. (Heavy and thick papers do not need stretching.) Paper can also be bought in sheets stuck together on the edges of all four sides to prevent cockling. These are called watercolour blocks, they come in various sizes and are excellent for use out-of-doors. When the painting is finished, you simply tear off the sheet and work on the next one.

WEIGHTS OF PAPER

The weight of the paper is arrived at by calculating how much a ream (480 sheets) weighs. For instance, if a ream weighs 300 lb (which is about the heaviest paper you can use) then the paper is called (with its manufacturer's name and surface

title) Waterford watercolour paper 300 lb Not. You will find that a good weight to work on is a 140 lb (285–300 gsm) paper.

If this sounds complicated, don't worry. To start with, get used to two or three types of paper. You will learn how the paper reacts to the paint and what you can and can't do. This is as important as getting used to your brushes and colours.

When you first buy paper, pencil the name, size and weight in each corner for future reference. On page 12 different pieces of watercolour paper are shown, reproduced their actual size. I have put some paint on each one and I have also given its full description.

When you have practised and have become more confident in handling your colours without spoiling too much paper, my advice is to buy the best paper you can afford and stick to that one until you know it like the back of your hand.

In fact, the better you know your brushes, your paints and your paper, the more you will enjoy painting – and the better your results!

OTHER MATERIALS

Other items you need are pencils – start by getting an HB and 2B (the other grades up to 6B, the softest, I will leave to your own choice); a good quality, natural sponge for wetting the paper or sponging off areas you want to repaint; blotting paper for absorbing wet colour from the surface of the paper in order to lighten a passage that is too dark; and a brush case when you are painting outside to avoid damaging your brushes.

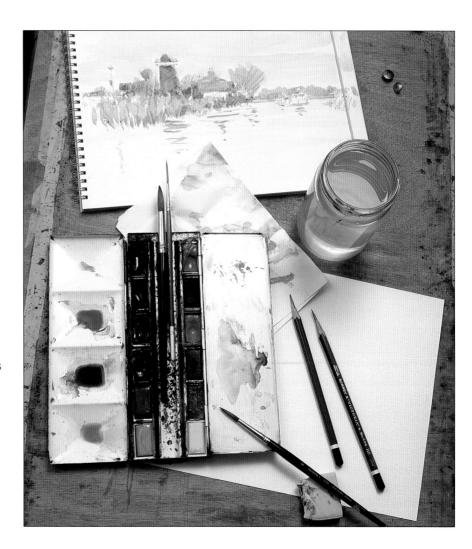

▲ *Beginner's basic equipment.*

You will need a drawing board on which to pin your paper. You can make one from a smooth piece of plywood or you can buy one from your local art shop. A container to hold your painting water can be anything from a jam jar to a plastic cup but make sure that it is big enough to hold plenty of water.

A kneadable putty eraser is the best type to use for rubbing out as it can be used gently on delicate paper without causing too much damage to the surface.

When you are using a pen and wash technique in the exercises, you will require a mapping pen and black Indian ink (waterproof).

BASIC WATERCOLOUR KIT

Now for your essential equipment: you will see what you need in the picture above. You can start with only three brushes: a No. 10 round brush (the quality you get will depend on price), a No. 6 round brush for general detail work, and a Dalon Series D99 'Rigger' No. 2 brush for fine line work. You need a paint box to hold your colours in half pans or whole pans, HB and 2B pencils, a kneadable putty eraser, a drawing board, paper, blotting paper, a sponge and a water jar. I haven't included an easel because it is not an essential piece of watercolour equipment;

when you are working outside, your painting is usually small enough to manage on a drawing board resting on your knees.

This short list represents the advantages of watercolour: its equipment, its approach and its execution are simple. However, although you can have a lot of fun with it, you can achieve complete control over watercolour only after a great deal of experience.

USING MOUNTS

Usually a watercolour isn't painted right up the the edge of the paper so it is a good idea to have some mounts for offering up to a finished watercolour. You will then be able to see where the painting will be masked when it is framed. Cut mounts of various sizes from cartridge paper or thin card and, when you have finished a painting, put a mount around it to see what you think. This will help you decide whether you think your picture looks finished or not.

WORKING AT AN EASEL

Back to the drawing board – or easel! You can work very comfortably at a table, with the top edge of your drawing board supported by a book or piece of wood about 8–10 cm (3–4 in) high so that the washes can run down correctly. If you want to work on an easel, choose one from the variety on the market.

▶ *A selection of painting materials that you can use as you progress and become more experienced.*

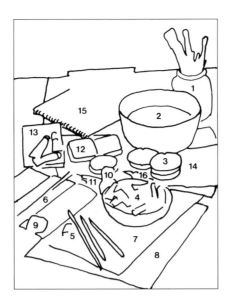

1 A selection of brushes
2 Water container
3 Mixing palettes
4 Tubes, whole pans and half pans of paint
5 Putty eraser, brush and pencils
6 Watercolour box with whole pan
7 Tinted watercolour paper
8 Watercolour paper
9 Sponge
10 Black ink
11 Pens
12 Small watercolour box with half pans
13 Mixing palette and tubes
14 Blotting paper
15 Watercolour pad
16 Knife

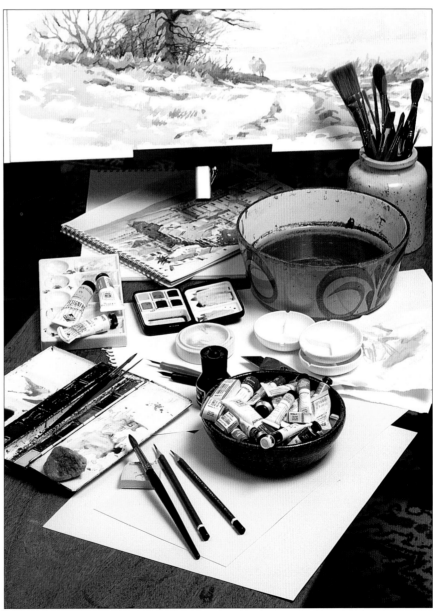

LET'S START PAINTING

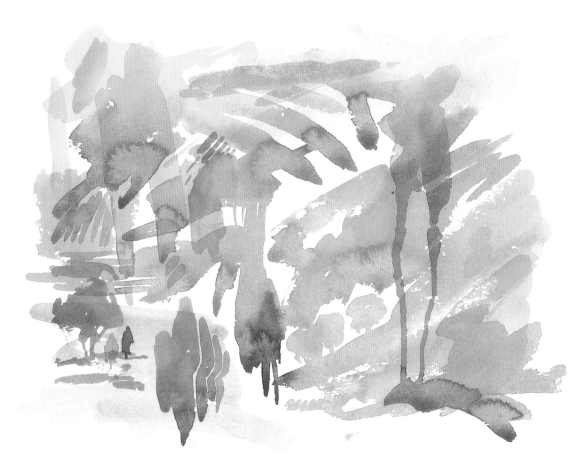

Now at last, you can start painting! Many people who haven't painted before find this the most difficult bridge to cross – to actually put some paint on paper. Unfortunately, we are all self-conscious when doing things we haven't tried before and our families don't help either!

I have often come across the case of a relative who sees someone's first efforts at painting. Remarks such as 'What's that!' and 'Well, never mind' are never meant to be unkind, but can put off a sensitive beginner – sometimes for ever. It's human

nature for us all to strive to do better but, if we try to run before we can walk, then disaster will strike and cause those humorous comments from the rest of the family. So we will start at the very beginning and take things in a steady, progressive order. I'll see you don't run first!

PLAYING WITH PAINT

First, take a piece of watercolour paper or cartridge paper and play with the paint on this. See what it feels like, try different brushes,

▲ *Just doodle with the paint and see what happens.*

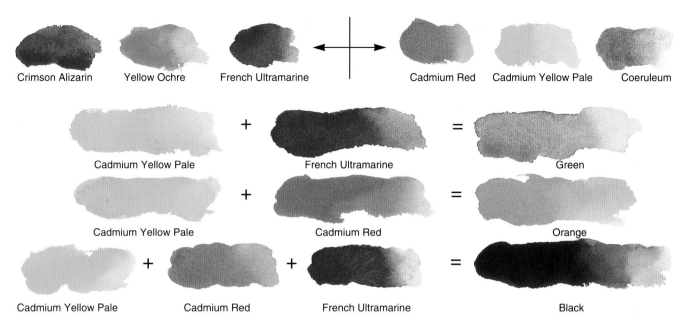

add more water, less water and mix colours together. You will notice that if you add more water you make the colours lighter. This is the correct method for making watercolours lighter, not by adding white paint.

You will end up with a funny-looking painting! If the family laugh at this, laugh with them – show them my doodles and laugh at that, too. What you've done is experienced the feel of watercolour paint. It isn't a stranger to you any more, nor are your brushes or paper. You have broken the ice and will feel much more confident in tackling the next section. Good luck.

PRIMARY COLOURS

A beginner may find the hundreds of colours that exist quite overwhelming but the choice can be simplified. There are only three basic colours: **red**, **yellow** and **blue**, the 'primary colours' and all other colours and shades of colour, are formed by a combination of these three. In painting, there are different reds, yellows and blues which we can use to help recreate nature's colours. In the illustration above you will see there are two of each primary colour. As I explained earlier, these colours, plus three more, are the ones I use for all my watercolour painting.

MIXING COLOURS

In the illustration above, I have taken these primary colours and mixed them to show you the results. Cadmium Yellow Pale mixed with French Ultramarine makes green. Cadmium Yellow Pale mixed with Cadmium Red makes orange.

One golden rule when mixing colours is always put the predominant colour in first and mix into this with smaller amounts. For example, if you want a yellowy-orange, put yellow into the palette first and then add a smaller amount of red to it. If you want an orangey-red, put red into the palette first, then add a small amount of yellow. Add more water to make the orange paler.

I have also shown you how to mix black. Some artists use black paint; others don't. I am one of the don'ts because I believe it is a dead colour and too flat. I mix my blacks from primary colours and suggest you do the same. In general, if you want a colour to be cooler, add blue. If it is to be warmer, then add red.

Spend time practising mixing different colours on cartridge paper. Mix the colours on your palette with a brush and paint daubs on to your white paper. Don't worry about shapes at this stage, it's just the colours you're after. Practise and experiment – that's the best advice I can give you. Even when you're just sitting relaxing, look around you, pick a colour that you can see and try to imagine what colours you would use to mix it.

This lesson of mixing colours is one that you will be practising and improving upon all your life – I still am!

BRUSH CONTROL

Now you must learn to control the paint brush. Like all things, when you know how, it is much easier than you had thought. A lot of control is required when painting edges of areas that have to be filled in with paint, such as the outline of a pair of scissors shown opposite, so first practise this simple exercise.

STRAIGHT LINES

Now let's go on to straight lines The next exercises involve drawing boxes and you should do these freehand.

A very important rule to remember when you draw straight lines (unless you are drawing very short ones) is always to move your wrist and arm – not your fingers.

Try drawing a straight line downwards, moving only your fingers. You will find that you can draw only a few centimetres before your fingers make the line bend. Now draw another straight line but this time keep your fingers firm and move only your hand, bending your arm at the elbow. The result will be a long straight line.

First practise the boxes shown opposite and then try drawing your own shapes and filling them in with your own colour mixes. Look around you and choose a colour – perhaps the colour of your carpet or a cushion – then try to mix a colour like it to use for painting in your shapes.

You will be practising all you have learned so far, in one exercise. Well done – but do keep at it! The more you practise, the more your painting will progress.

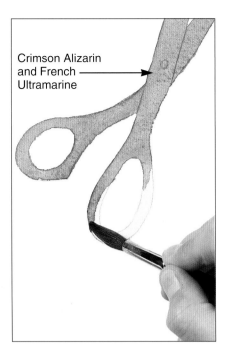

Crimson Alizarin and French Ultramarine

◄ Take a pair of scissors, or anything handy that has round shapes, and draw round it with an HB pencil. You can do this on cartridge paper or watercolour paper. Use your round sable brush with plenty of water. When you start to fill in the curved shapes, start at the top and work down the left side, to the bottom. Let the bristles follow the brush, i.e. pull the brush down. Try to do this in two or three movements. When you paint the right side of the handle, your brush will cover some of the pencil lines and you will feel slightly awkward. The answer is to accept that it feels a bit awkward but the more you use your brush like that, the more natural it will feel – practise!

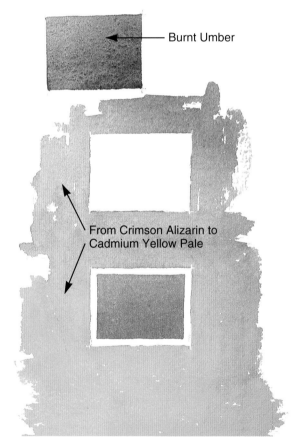

Burnt Umber

From Crimson Alizarin to Cadmium Yellow Pale

▲ Draw a square with pencil, then paint the edges of the box using your round sable brush and use this same brush for filling in the square with the rest of the paint. Then draw another two squares and paint both up to their outside edges. Change the colour as you paint, working from above the first box to below the second one. Then paint another box inside the second one, without drawing it first. This exercise should keep you busy!

SIMPLE PERSPECTIVE AND DRAWING

Drawing, or the knowledge of drawing, comes before painting and, therefore, we will take a little time to practise simple perspective. If you believe you can't draw, don't let this worry you. Some artists can paint a picture but would have difficulty in drawing it as a drawing in its own right. It is the colours, the tones and the shapes of the masses that make a painting.

When you look out to sea, the horizon will always be at your eye level, even if you climb a cliff or lie flat on the sand. So the horizon is the eye level (**EL**). If you are in a room, naturally, there is no horizon but you still have an eye level. To find this, hold your pencil horizontally in front of your eyes at arm's length: your eye level is where the pencil hits the opposite wall.

VANISHING POINT

If two parallel lines were marked out on the ground and extended to the horizon, they would come together at what is called the vanishing point (**VP**). This is why railway lines appear to get closer together and finally meet in the distance – they have met at the vanishing point.

The next exercise is the most important one you will ever do. You are creating on a flat surface the illusion of depth, dimension and perspective; in other words, a three-dimensional object.

We are looking down on this box because the eye level is high. Turn the book upside down and the eye level will be low and you will be looking underneath it.

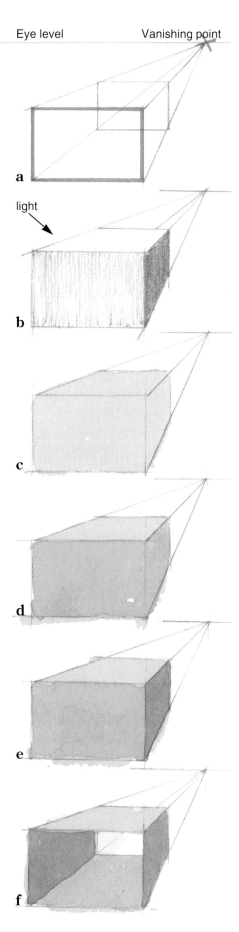

Eye level Vanishing point

light

a Here I started by drawing the same square as in the previous exercise. Then I drew a line above it to represent the eye level. To the right-hand of the **EL**, I made a mark, the vanishing point. Then, with a ruler, I drew a line from each of the four corners of the box, all converging at the **VP**. This gave me the two sides, the bottom and the top of the box. To create the other end of the box, I drew a square parallel with the front of the box and kept it within the **VP** guide lines. The effect is that of a transparent box drawn in perspective.

b Here I have shaded the box with pencil to show the light direction.

c The same box was painted all over with a wash of Hooker's Green No. 1. It has no form and looks flat and unrealistic.

d This box is painted with a second wash over two sides when the first wash had dried. I have 'turned the light on' and the box is starting to take shape.

e This was painted with an additional wash on the darkest side, which made the box appear solid.

f Here I have painted the same drawing to represent a hollow box.

19

BASIC TECHNIQUES

Before you start these basic techniques, read the next three paragraphs carefully.

When you put the first wash on the box in the exercise on page 19, did you notice that, although the box was drawn in perspective, it looked flat? This is because there was no light or shade (light against dark). It is this light against dark that enables us to see objects and understand their form.

If we were to paint our box red, on a background coloured the same red, without adding light or shade (light against dark) we wouldn't be able to see it. If light and shade were added, it could then be seen. You must always be conscious of light against dark whenever you are painting. When you are painting a still life or outside, it will help you to see shapes if you look at the scene through half-closed eyes. The lights and darks will be exaggerated and the middle tones will tend to disappear: this will enable you to see simple, contrasting shapes to follow.

You will see that, while your colour is wet, it appears dark and rich but when it is dry, it is slightly lighter. You will learn from experience how to adjust the density of your colours in order to achieve the desired effect. In the meantime, don't worry – it won't spoil your paintings. Don't get too depressed if you feel a painting has gone wrong or out of control. It happens to the best of watercolour artists – it's part of watercolour painting.

Remember: you can learn a lot from your mistakes!

▼ Flat wash
For a flat wash (the most basic technique of watercolour painting), you need plenty of watery paint in your palette. Load your largest brush and start at the top, left-hand, taking the brush along in a definite movement. Don't rush. When you get to the end, bring the brush back, run it slightly into the first wet stroke and make another brush stroke like the first. You will, of course, add more paint to your brush when you need it. Because the colour was mixed before you started the wash and you have added no more water, the colour density of the wash should be the same all the way down.

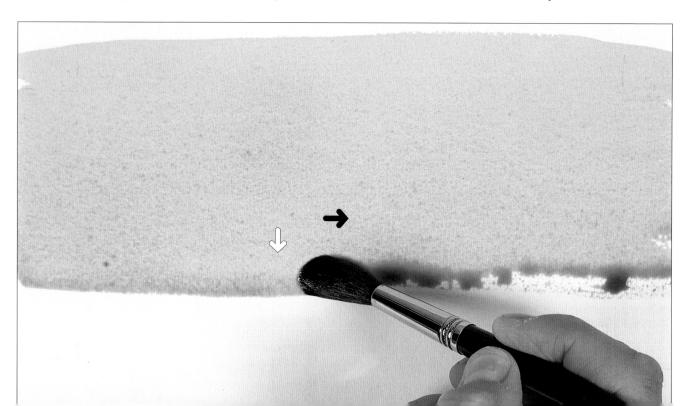

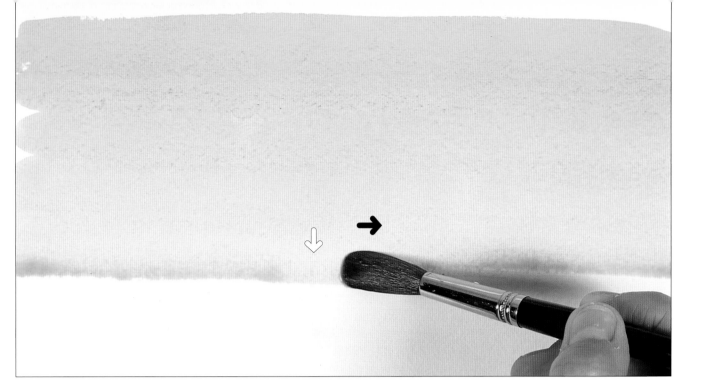

BRUSH MOVEMENT

In all instructive illustrations, I have used arrows to help you understand the movement of the brush. The solid-black arrow shows the direction of the brush stroke and the outline arrow shows the direction in which the brush is travelling over the paper. For example, the flat wash (left) shows the brush stroke moving horizontally, from left to right, and the brush moving down the paper after the completion of each horizontal stroke.

When using colours, your colours must always be in the same position in your paint box and you must always use the box the same way round. You have enough to think about, without wondering where your colours are, when you are in the middle of painting a wash! The position of the colours in my box is shown on page 14 and I have my box with the deep wash pans (in the lid) on the left of the box. I was taught to work this way at art school and I have done so ever since.

▶ Wash-over-wash
Paint a wash. When it is completely dry, paint another one over it, leaving about 1 cm (½ in) at the top of the original wash. If you repeat this process at least six times, you will begin to get the knack of putting on a wash. You will also be practising the watercolour technique of applying transparent colour over and over again, and you will see that the more washes you apply, the darker the colour becomes.

▲ Graded wash
Do this in exactly the same way as the flat wash except that, as you travel down the paper, you add more clean water to the colour in your palette. This weakens the density of the colour, so that the wash gets progressively paler from top to bottom.

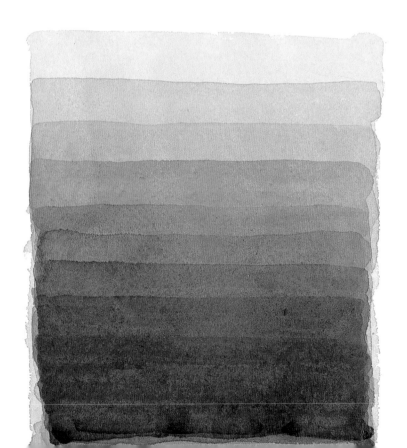

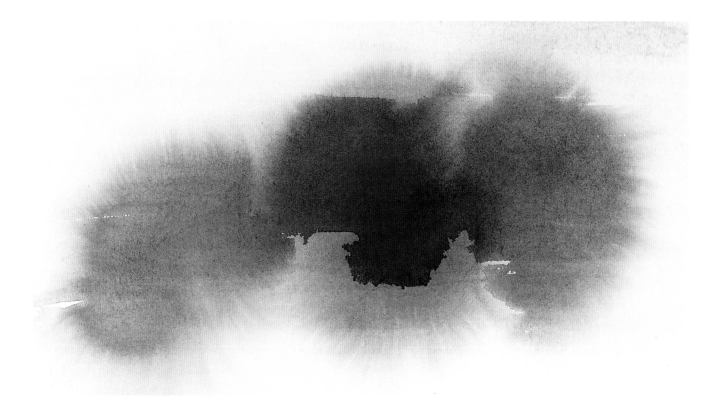

WET-ON-WET TECHNIQUE

The term 'wet-on-wet' is common to all painting mediums. It means that wet paint is applied over existing wet paint.

It is one of the most intriguing watercolour techniques. It is impossible to predict exactly what will happen when you put wet paint on top of a wet wash, as you can see from my examples. This is precisely why it is such a fascinating technique. You will create some fantastic effects – some of them dramatic, others very subtle.

If you wait until the first wash is drying, you will have much more control over the paint and will also achieve a slightly different effect.

You can get good skies, using the wet-on-wet technique, by wetting your paper first with a sponge or brush with clean water, then painting your sky colours and letting them run together. You really need to experiment a lot with this technique and practise control. The overall effect should be planned – it's the unpredictable wanderings of the paint that add interest and beauty.

When it is dry, you might see an area that, by happy accident, needs only a brush stroke to make it read better: if the brush stroke is applied correctly, this passage could be a little gem in the painting.

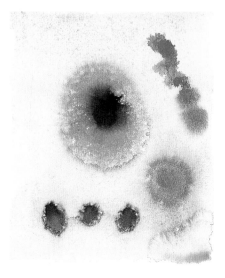

▲ *In this experiment, I painted Coeruleum first, very wet. Then I added a mix of Payne's Grey and Burnt Umber, very wet, in the middle. When this was dry, I lightly sponged it with clean water, and then attacked the middle again with a mix of Payne's Grey, French Ultramarine and Burnt Umber – this makes very strong colour. Immediately, I then added more water to the colour mix and put a daub of paint on each side of the centre.*

◄ *I used Coeruleum, Burnt Umber and Payne's Grey again for this wet-on-wet experiment. The effect is quite different this time – I think it looks like a selection of jewels!*

DRY BRUSH TECHNIQUE

The dry brush technique is also used in most types of painting.

This simply means that a brush is damp-dried before being dipped into paint, or else a wet brush is loaded with paint, dried out to a damp consistency on a piece of blotting paper, and then applied to the watercolour paper. The technique is used to achieve a hit-and-miss effect.

If you try this on rough watercolour paper it is relatively easy, but on a smooth-surfaced paper it needs a little more practice. The chances are that you accidentally produced a dry brush effect when you were doodling or painting the boxes earlier on – you were probably annoyed because you were running out of paint – but it was unintentional and, therefore, uncontrolled.

The best way to get used to the dry brush technique is to use long brush strokes, from left to right, with only a little paint (see the illustration, above right). You will find that your brush runs out of wet paint and finishes the stroke with a dry brush effect.

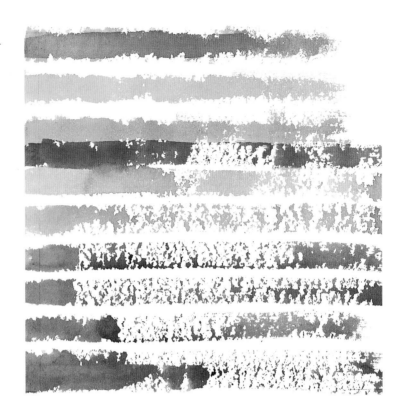

▲ *Try to control the amount of wet paint you load on to your brush and cover an area of about 30 cm (12 in) so that the stroke is finished with a dry brush. When you can do this, you have gone a long way towards controlling your watercolour brushwork.*

▼ *Because these are short dry brush strokes, painted to give the impression of bark on a silver birch tree, I was careful that my brush was reasonably dry when I applied the strokes.*

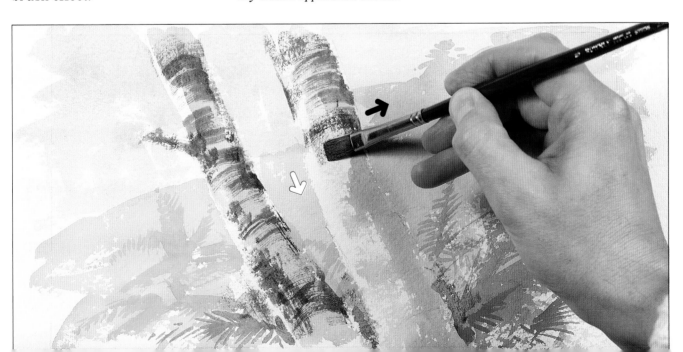

DIFFERENT WAYS TO PAINT

Watercolour is a very versatile medium. It can be used in different ways by different artists. For instance, six artists could paint the same subject, using the same technique, but each painting would be different because each artist would have his own style. Also my wet-on-wet watercolour, opposite, is painted in a very different style to my pen and wash watercolour on page 27. Therefore, an artist's style is, to some extent, altered by technique. To avoid confusion, in this chapter the word 'style' refers to the individual artist's way of painting and 'technique' refers to the method of using the paint.

COMPARING TECHNIQUES

On the next pages are six pictures I have painted of the same subject, using a different technique each time to show you the versatility and beauty of watercolour. By comparing several versions of the same subject you can see the difference between each technique. The actual size of each painting is 34 × 23 cm (13½ × 9 in) and the type of paper I used is indicated in the captions for each one.

I must point out that some subjects do not necessarily lend themselves to a particular technique and, on the other

▼ 2B Pencil on cartridge paper
I used this pencil sketch, which was done outdoors, as the subject for my paintings in this section. Incidentally, the black cat on the wall did come and play there for a few minutes, so I drew it, but I didn't put it in the painting. I felt it looked a little too contrived!

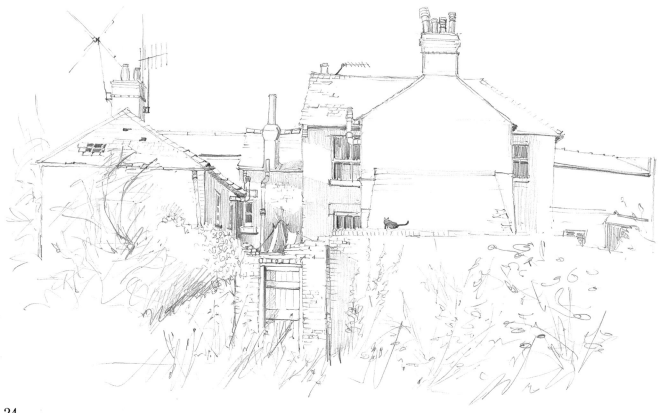

hand, some subjects cry out for just one technique. Therefore, you must choose your subject and technique carefully. Naturally, a pencil and wash or pen and wash drawing can be tackled only if you have a reasonable knowledge of drawing because this plays a large part in these two watercolour techniques.

Whatever the technique, the basis for the painting is still the wash, whether it be flat, graded or wet-on-wet which I have already shown on pages 20–22. I mention this at this stage because you just can't practise these enough – the wash *is* watercolour.

When you can master it on all scales, small and large, you will be much more relaxed when you work and you will find that fewer disasters come off the brush. So keep practising!

MODERN IMAGES

I must make an observation about the buildings in the paintings on these pages.

It has always been thought that something old – especially a

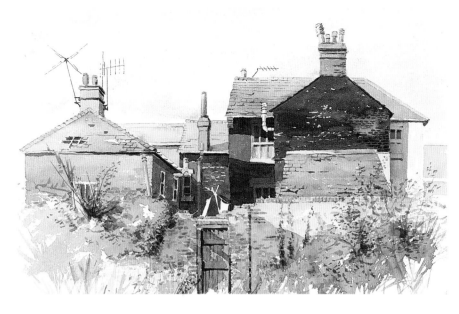

building – has plenty of character and provides a perfect subject for the painter, and I certainly agree with this. When television boomed in the 1960s, artists avoided the old buildings that had TV aerials fixed to them or just left the aerials out.

The strange thing is that, when I found the buildings for the pictures on the following pages, I felt that the TV aerials added to their character and charm. It is amazing how things gradually become accepted.

▲ Flat and graded wash techniques
Watercolour paper, 300 lb Not
I regard the flat wash and graded wash as basic, traditional ways of using watercolour. Having thought out the moves very carefully beforehand, you work up the effect with washes. Remember to use the lightest colours first and work gradually to the darker tones.

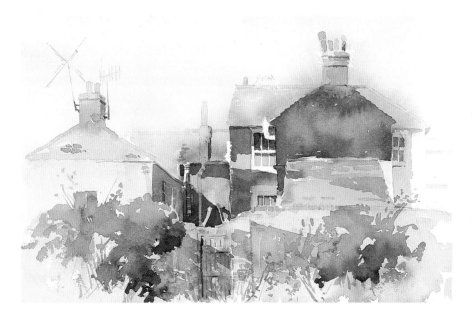

◀ Wet-on-wet technique
Watercolour paper, 300 lb Not
The wet-on-wet technique is a very exciting way of using watercolour but it can also be very nerve-racking. The freedom, the apparent ease and the sheer audacity of letting colours make their own way around the paper excites artist and onlooker alike. But, although the finished result looks natural and unlaboured, you have to put in many hours of patient practice.

BODY COLOUR

You can strengthen your colours by using the body colour technique. Simply add White to the paint and this will immediately take away the transparency of the colour.

When you are next painting a watercolour, if you find you have 'lost it', try using White with your colours and turn it into a body colour painting. Remember that light can be added over dark.

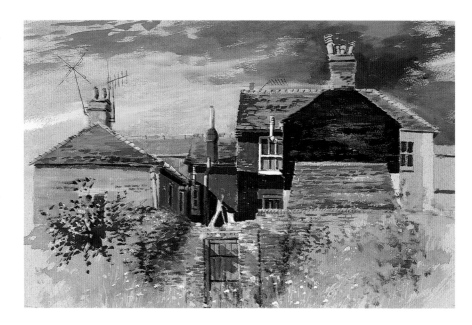

▲ Body colour technique
Tinted watercolour paper
Generally speaking, instead of water, White is used in this technique to make the colours lighter. In this painting, I made the sky dark for a dramatic effect and I used pure White where the sun catches the window frame.

OPEN WASH

I have called the technique 'open wash' because white paper is left between each wash.

Apart from its own charm, open wash has a very valuable application. When you are painting outside, it is often impractical to wait for each wash to dry before applying the adjacent one. If you use this method, you can carry on almost without stopping.

Don't be too rigid with the 'white lines'. Keep them free and let the paint touch and run together in places. This keeps the painting looking free and not too mechanical.

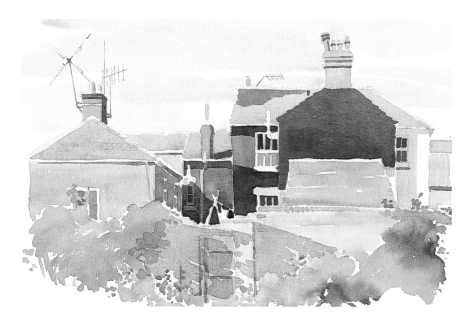

▲ Open wash technique
Watercolour paper, 300 lb Not
This painting looks a little flat when compared with the others but it demonstrates a crisp, clean watercolour technique.

PENCIL AND WASH

Pencil and wash is one of the most delicate ways of using watercolour. It can be very sensitive and detailed.

First, I did the drawing – as though it were to be a drawing in its own right. Naturally, the amount of detail you put in depends upon your drawing ability. All the shading was done with a pencil. Washes of colour were applied after the drawing was completed. Incidentally, this fixes the pencil and stops any smudging.

▲ Pencil and wash technique
2B pencil on tinted watercolour paper
Naturally, you want to be confident with your pencil work to try this technique but I am sure that you will enjoy it.

PEN AND WASH

Pen and wash is used at some time or another by many watercolour artists and it is a very popular technique. The addition of the pen gives a sparkle to the painting.

In my example opposite, I painted the picture first, then added the pen work, but you can work the other way round – pen first – if you find it suits you better.

Like body colour, the use of the pen is another method of saving a watercolour.

▲ Pen and wash technique
Watercolour paper, 140 lb HP
Next time you want to put a bit more sparkle into a painting, try using a pen – you could transform a mediocre painting into a masterpiece.

SIMPLE EXERCISES

You may have had a few funny experiences with the paint – losing control, or finding that runs of paint have broken away from the main wash and run down the paper on to the table or floor. But you will have learned a lot and can now use this knowledge to do some real painting.

If up until now you have been using cartridge paper or thin watercolour paper and haven't yet tried stretching any paper, now is the time to do so. It makes an incredible difference. Refer to the instructions on page 13.

Before you start a watercolour painting, you must always have clean water in your container. Remember, the paint stains the water to make the colour. If the water is dirty, obviously you will not get a true, clear colour.

To avoid breaking my rhythm when I am painting in the studio, I sometimes speed up the drying time of a wash by using a hair dryer to blow dry my wash. If you do this, don't hold the dryer too close – what you are trying to achieve is a quicker, natural way of drying your wash.

POTATO EXERCISE

I have chosen the potato, above, for your first exercise. The drawing is not too difficult and if you put a bump in the wrong place, it will not look wrong. Also, although the colour isn't bright or

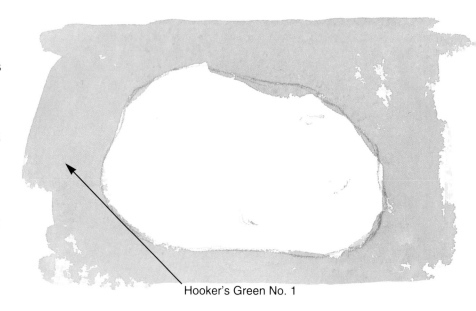

Hooker's Green No. 1

▲ *First, draw the potato with your HB pencil. Then, using your large, round brush, paint the background as a wash with Hooker's Green No. 1.*

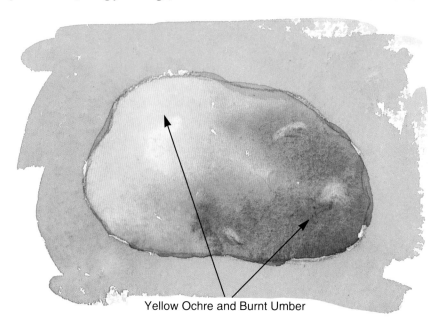

Yellow Ochre and Burnt Umber

▲ *When this is dry, paint the potato with a colour mix of Yellow Ochre and Burnt Umber, adding more colour on the shadow side as you paint down.*

While the paint is still wet, dry out your brush and wipe out some highlights. These are only subtle effects but help to give the potato form.

exciting, it can be matched easily. The colour of potatoes varies, so if you don't match it exactly, your painting will still look right.

You may now have the impression that if an object isn't represented correctly, it doesn't matter. Of course, this is not true. I am trying to make sure that your first painting of an object looks correct to your family and friends so that you will receive their praise and congratulations. This will boost your confidence which, in turn, will improve your work. Now you can understand why I chose a potato for you – because it has no specific shape or colour. When you can paint this potato, you will have come a long, long way. Now try some more vegetables – you will find that you enjoy painting them.

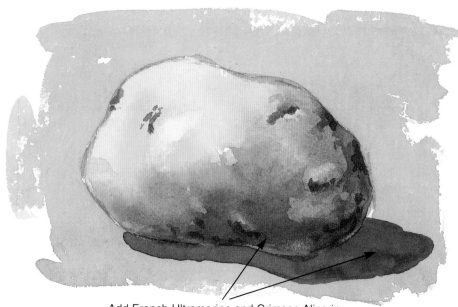

Add French Ultramarine and Crimson Alizarin

▲ *Before the paint dries, add French Ultramarine and Crimson Alizarin to your mix for the dark blemishes. As the paint is still slightly wet, these marks* will run a little and the edges will be soft. Then put in the shadow. Don't be fussy with the detail and, if it doesn't work the first time, keep trying.

SIMPLIFYING A COMPLICATED SUBJECT

Opposite is a complicated pencil sketch I made of the River Hamble in Hampshire. I put quite a lot of drawing into this but, if you just wanted to paint it, you could manage by sketching only the key positions – the horizon, the wooden quay and a couple of the main boats – the brush could do the rest. I used a rough surface paper for this, a lot of dry brush, and I scratched out the light on the middle-distance water with a blade.

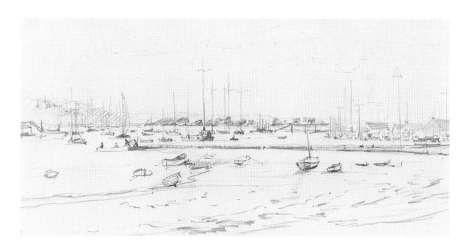

▶ *Although this painting was simplified, I made sure that the white yacht and the white rowing boat were carefully worked because these were at the centre of interest.*

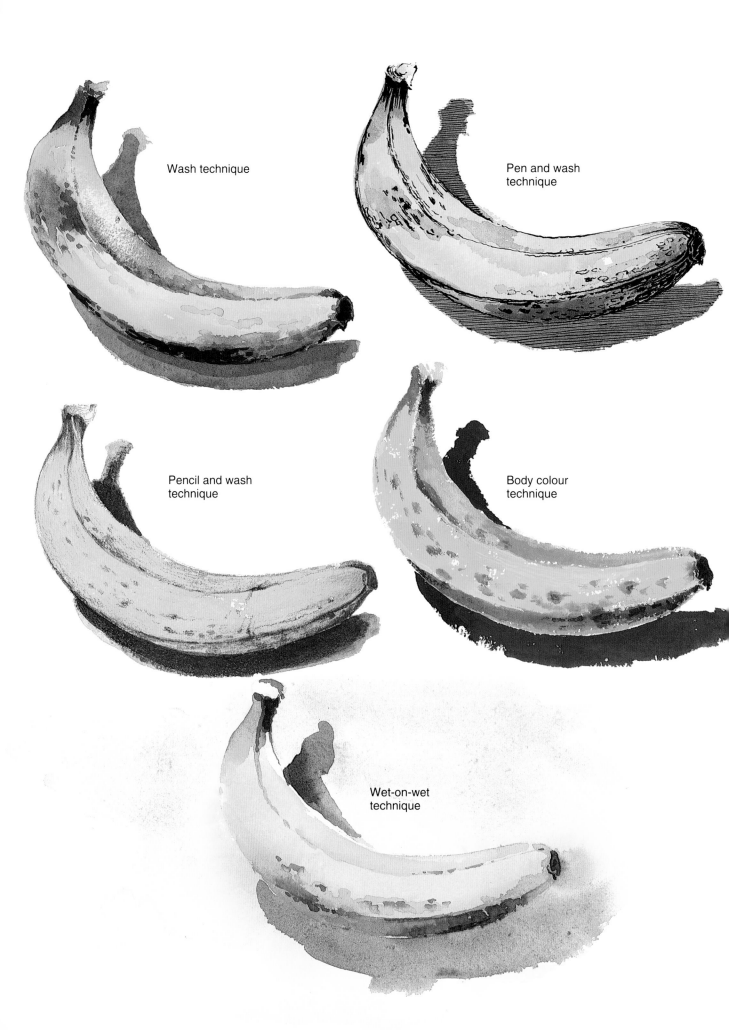

Wash technique

Pen and wash
technique

Pencil and wash
technique

Body colour
technique

Wet-on-wet
technique

BANANA EXERCISE

Next try this very simple approach to five of the techniques I described earlier. Draw five bananas on the same sheet of paper with your HB pencil and then paint the banana shapes, using the same colours for each technique.

COLOURS
Cadmium Yellow Pale; Burnt Umber; Crimson Alizarin; French Ultramarine.

WASH TECHNIQUE
Use your large round brush and let the brush strokes follow the shape of the banana. When the paint is almost dry, put on a darker wash and add some darker marks on top. Then paint a dark shadow wash to show up the banana (light against dark). Put in a few dark accents with your No. 6 brush to crispen it up.

PEN AND WASH TECHNIQUE
Paint this banana in the same way. When the wash is dry, use a mapping pen and black Indian ink to draw the banana. Experiment to find your natural style. If you prefer, you can try drawing the banana with pen and ink first before putting coloured washes over the top.

PENCIL AND WASH TECHNIQUE
Draw and shade the banana with your 2B pencil as if you were doing a pencil drawing. Then paint it in the same way as the first one but, this time, over your pencil shading.

BODY COLOUR
Paint this banana using the same colours as before but this time add White to make the paint lighter and more opaque – don't use a lot of water. You will find that the paint does not flow so easily and you have to work it more than usual.

Usually white poster colour or a tube of white gouache colour is used and you must wash it off your palette when you have finished with it. If white paint gets accidentally mixed with watercolour and applied to paper, and you put a wash over the top (or even a very watery brush), it will run and ruin your work.

WET-ON-WET TECHNIQUE
Use your sponge or large brush to wet the paper and, while it is still quite wet, paint the banana with the same brush. The colours will run over the edge of your pencil drawing. Then paint the darker side and add some dark blemishes. When this is nearly dry, use the same brush to paint your background. Start at the left, above the banana, and follow its top shape in one brush stroke, then work underneath it.

ROSE EXERCISE

This exercise is a little more difficult than the banana, but I am sure you can do it!

COLOURS
Cadmium Red; Crimson Alizarin; Hooker's Green No. 1; Burnt Umber.

FIRST STAGE
Use your No. 6 brush to put a wash of Crimson Alizarin and Cadmium Red on the flower. While this is still wet, wipe out some of the paint for highlights with a damp brush. Paint the stem and leaves with a mix of Hooker's Green No. 1 and Crimson Alizarin and, while the

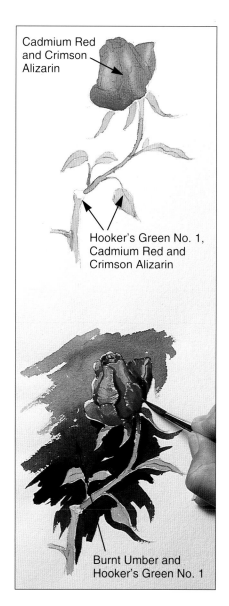

Cadmium Red and Crimson Alizarin

Hooker's Green No. 1, Cadmium Red and Crimson Alizarin

Burnt Umber and Hooker's Green No. 1

leaves are still wet, add some Cadmium Red with the point of the brush.

FINISHED STAGE
Now paint the petals with stronger colour and, when dry, scratch out some highlights. With the same brush, paint the background – make sure your paint is very wet and use a colour mix of Burnt Umber and Hooker's Green No. 1. Be definite when painting up to the leaves – let the brush stroke make the shape. Finally, add some shadow on the stem and leaves under the flower.

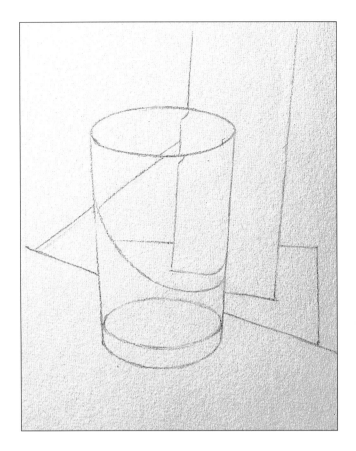

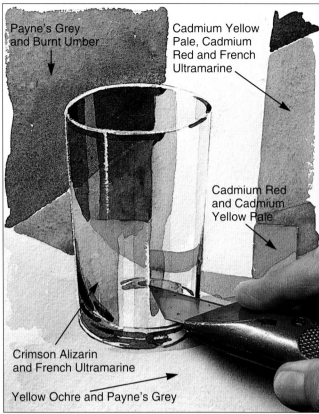

Payne's Grey and Burnt Umber

Cadmium Yellow Pale, Cadmium Red and French Ultramarine

Cadmium Red and Cadmium Yellow Pale

Crimson Alizarin and French Ultramarine

Yellow Ochre and Payne's Grey

GLASS EXERCISE

I find that most students fight shy of painting this still life subject and I am often asked how to make a glass object actually look like glass.

The answer, as always, is by observation. Try to look right through the glass and analyze the shapes behind it. Then draw the glass and simplify these reflections. Once you have completed this exercise, set up your own glass and study the background shapes. You will need to practise, but I am sure you will soon learn the secret of painting glass.

▲ *If you look at my drawing, you will see that definite shapes are formed in the glass. When painting it, I used a large brush to work the top-left dark area first, leaving the rim of the glass white paper and painting into the glass itself. Then I painted the orange areas. Next, using a very pale wash for the white areas, I left some unpainted white paper in the glass. I put in a dark wash down the left-hand side of the glass. For this I used downward strokes and I left some areas untouched. When this wash was completely dry, I went over the area again with even darker colour and then I added a few dark accents using my small sable brush. Finally, I used a sharp blade to scratch out some highlights on the glass.*

SKY EXERCISE

I have already said that the wash is the basis of all watercolour painting and if you have been practising your basic techniques, you should now be able to

handle a wash quite confidently.

The last two exercises – the rose and the glass – needed a lot of hard thinking and careful brush work but you can be a little more relaxed when painting skies. After all, if you get the overall shape of a cloud correct, it doesn't matter if you have an extra bump here and there.

Skies are one of the best subjects on which to practise washes and large brush work. You will also find that, even if it is just an exercise, you can produce a very rewarding painting when painting skies.

Tackle this exercise for the sheer joy of painting and enjoy the freedom that the paint and the subject matter allows. The six paintings on the opposite page were all done on watercolour paper, 300 lb Not, 12.5 × 17 cm (5 × 7 in), but you can try all kinds of paper, surfaces, weights, colours, sizes and so on.

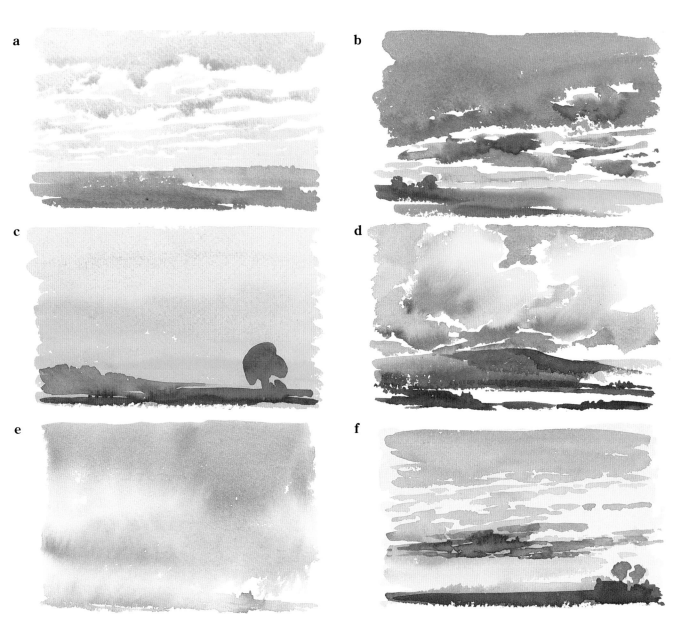

a *On this clear, windy day the clouds were moving quite fast. I used dry paper and a No. 10 brush to paint a wash of Coeruleum and a little Crimson Alizarin for the blue sky. While it was wet, I added Yellow Ochre to the mix and used it for the shadow of the clouds.*
b *I applied a wash of Payne's Grey, French Ultramarine and Crimson Alizarin to dry paper with a No. 10 brush, leaving white areas for clouds. While this was wet, I painted the darker sides of the clouds, then added a touch of Yellow Ochre to the dark shadows.*
c *This evening sky was a normal graded wash worked from the top to the horizon, and below the land. The paper*

was dry and I used Coeruleum, Crimson Alizarin and Cadmium Yellow Pale for the wash and worked with a No. 10 brush.
d *The big, full clouds were painted with a mixture of Yellow Ochre, Crimson Alizarin and French Ultramarine. Before they dried, French Ultramarine mixed with Crimson Alizarin (blue sky) was painted between them, leaving white edges – a silver lining to help merge the clouds. The little silhouette of the cottage at the bottom left and the white lake at the foot of the hills give dimension to the clouds.*
e *A very wet, drizzly day. The paper was soaked with a sponge except at the*

bottom right-hand corner. A mix of French Ultramarine, Crimson Alizarin, Payne's Grey and Yellow Ochre was worked on to the wet paper and you can see the result. Where the paper was dry at the bottom right, I let the brush form the cottage – again to give atmosphere and dimension.
f *I applied a normal wash of Crimson Alizarin and Cadmium Yellow Pale over the paper for this evening sky. When this was dry, I painted the clouds, using a No. 6 brush and adding French Ultramarine to the colour. Before these clouds were dry, I worked a darker wash over them to form the dark clouds just above the horizon.*

STILL LIFE
DEMONSTRATION

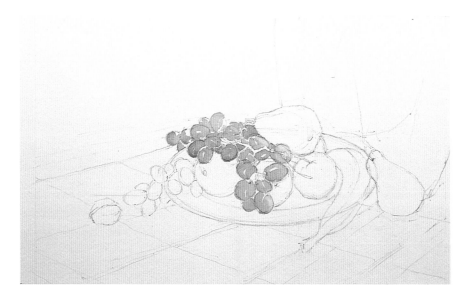

▲ *First stage*

On the following pages, I have taken nine subjects and worked them in stages for you to follow, and copy if you wish. In each demonstration, I have explained how to do the work and shown the painting from the first stage to the finished stage so you see the same painting through to completion and can refer back to see what was done in earlier stages. Since it is important for you to know the size of the finished painting because this gives you a relative scale to adjust to, the actual size is indicated under the finished stage for each painting.

Close-up illustrations for each exercise are reproduced the same size as I painted them so that you can see the actual brush strokes and details. I have also used insets to illustrate the method of painting passages that I think you need to see more closely.

For my first demonstration, I have purposely chosen a still life subject because the objects are easy to find but, above all, they can be painted under your own conditions. This is the beauty of still life: you can control the lighting, size, shape and colour of your subject. If you use inorganic objects, you can paint the same ones for years. But to avoid you spending that long on your still life, this one is mainly fruit!

COLOURS
Yellow Ochre; French Ultramarine; Hooker's Green No. 1; Crimson Alizarin; Cadmium Yellow Pale; Cadmium Red.

FIRST STAGE
First I drew the picture with my 2B pencil. I did the plate first and then the fruit. Notice how the plate pencil lines show through the fruit – this helps you to

construct the drawing. (If you want to remove pencil lines later, you can rub them out gently with a putty eraser.)

I painted the green grapes first using my No. 10 brush and a watery mix of Yellow Ochre, a little French Ultramarine, Hooker's Green No. 1 and Crimson Alizarin. Each grape was painted individually and I left white paper for highlights and the stalk.

SECOND STAGE

I then painted the black grapes in the same way as the green ones, using a mix of Crimson Alizarin, French Ultramarine and a touch of Yellow Ochre. The walnut was next and for this I used Yellow Ochre and a touch of Crimson Alizarin.

I used a mix of Cadmium Yellow Pale and Cadmium Red for the orange but added some of the dark grape colour as I worked down the right-hand side near the bottom. Notice the white paper highlights I left.

Next, I painted in the apples with a mix of Cadmium Yellow Pale and Hooker's Green No. 1, adding a little of the 'orange' colour to warm up the green.

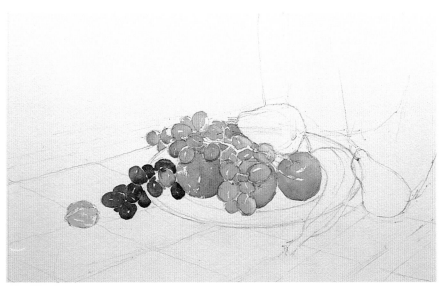

▲ *Second stage*

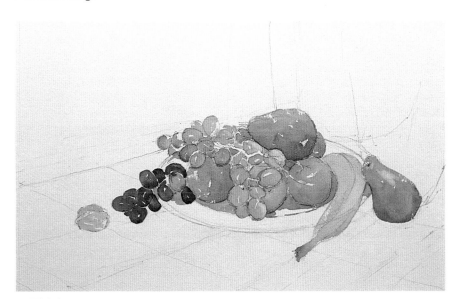

▲ *Third stage*

● When painting still life, don't be too ambitious to start with.

● Set up just a few objects that have simple shapes and colours, and put them on a contrasting background.

● The best light source is an adjustable desk lamp which can be plugged in near to your subject and then directed to give maximum light and shade.

THIRD STAGE

I painted the pear in the centre next, starting at the top with a mix of Cadmium Yellow Pale and Hooker's Green No. 1. As I worked down, I added a mix of Yellow Ochre and Crimson Alizarin for the 'browny' areas. I also added a little French Ultramarine to make it darker.

I used Cadmium Yellow Pale and a touch of Crimson Alizarin for the banana. Then I worked the last pear in the same way as the first, but made it greener. While the paint was still wet,

I wiped out a dull highlight on the pear with my damp brush. Next I put in the green apple behind the first pear. Notice that I have painted it larger than the drawing.

Finally, I painted in the shadows on the plate to establish the fruit firmly on it.

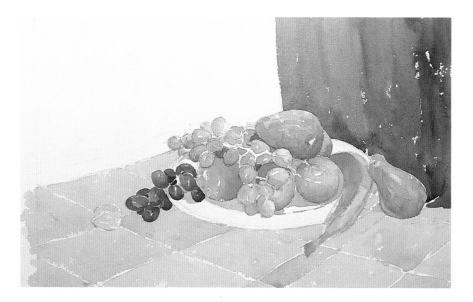

FOURTH STAGE

By now, I had put a first wash on all of the fruit but there wasn't much depth or detail.

It is at this stage that darker washes can be applied to give more depth, and a little more detail should be added. I used the same colours as before but added more pigment to make them darker.

I started with the black grapes, painting dark shapes on them with my No. 10 brush that followed the natural curve of each grape. You can see this in the detail, shown below. Again, I left white paper for the grape highlights. Then I did the green grapes. The light source was coming from the top right of the still life, so shadows were cast to the left.

I worked the orange next. Then, using my No. 6 brush, I added more work to the two apples, next to the banana and then to the pears.

I changed to my No. 10 brush for the dark material background and used a strong colour mix of French Ultramarine, Hooker's Green No. 1 and a touch of Crimson Alizarin and Yellow Ochre. I varied the colour as I worked down and used very free downward brush strokes.

Finally, using my No. 10 brush, I mixed two washes for the tablecloth: one of French Ultramarine and a touch of Cadmium Yellow Pale, and the other of Cadmium Yellow Pale, Cadmium Red and a little French Ultramarine. Notice how I left a thin line of paper between the coloured areas to stop my colours from running together.

▼ *I painted the shadow on the background using plenty of watery paint and diagonal brush strokes.*

▶ *Detail (actual size)*

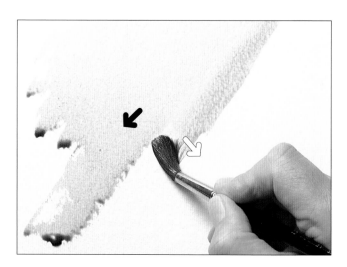

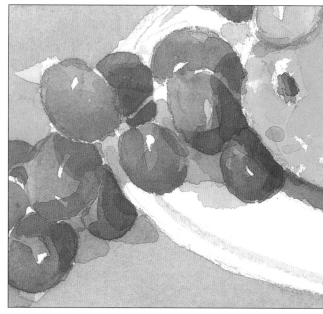

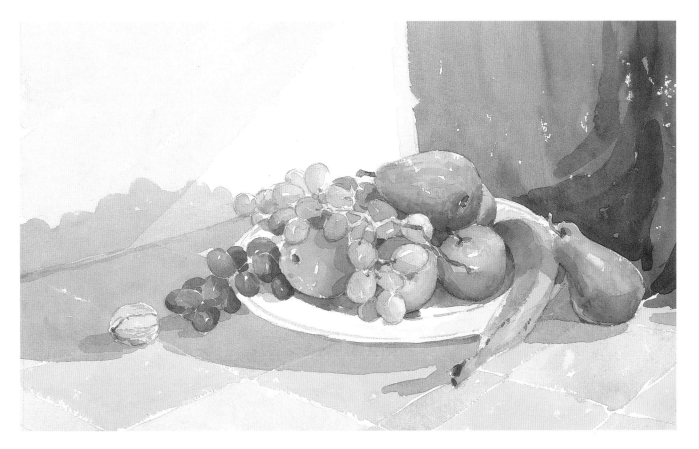

FINISHED STAGE

I added more shadows and detail on the fruit with my No. 6 brush and painted in the grape stalks.

Next I worked a darker green shadow area on the background material using my No. 10 brush. Then I painted the shadow of the plate and fruit on the tablecloth and wall with a wash of French Ultramarine, Crimson Alizarin and a touch of Yellow Ochre.

Finally, when this was dry, I applied another wash with the same colours on the wall only, going over the previous wash.

▲ *Finished stage*
Still life
Waterford 300 lb Rough
33 × 50 cm (13 × 20 in)

◀ *Detail*
(actual size)

▼ *I used my No. 6 brush to add some detail where I felt it necessary but was careful not to overwork this.*

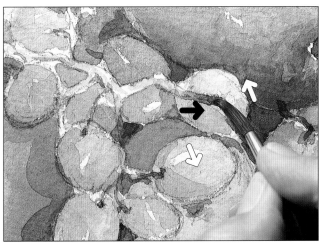

37

FLOWERS
DEMONSTRATION

This type of painting isn't a botanical one – remember, you simply want to give an impression of the flowers. Also, don't run before you can walk! A vase of different blooms with exciting shapes and colours can be a tremendous inspiration and make a fine painting. It can also be a daunting prospect for the beginner and, if attempted at an early stage, can lead to disaster and disappointment.

Study one species at a time. Put a single flower against a plain, contrasting background so that you can observe its characteristics: see how the petals are formed, their shape, how the flower head grows from the stem and, just as important, study the leaves. When you have mastered a certain flower, put some in a vase and paint away. You may find it helpful, at times, to use other colours in addition to those in your watercolour box because the colours of flowers are infinite.

For this demonstration, I have chosen flowers that could be painted with the colours I normally use and which have been used throughout this book. I worked them in a much looser style than the still life, using a much broader treatment and not worrying as much about detail. You must get yourself into the right frame of mind to start this kind of painting. It is not one to be worked on for days; it should be very direct and unlaboured.

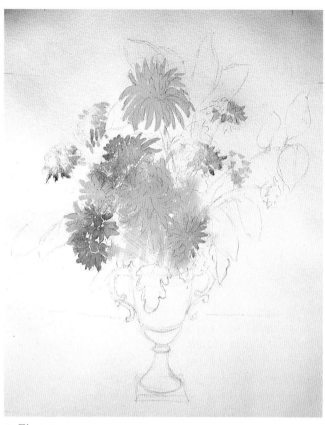

▲ *First stage*

COLOURS
Cadmium Yellow Pale; Crimson Alizarin; Coeruleum; Hooker's Green No. 1; Payne's Grey; French Ultramarine; Yellow Ochre.

FIRST STAGE
I drew the picture first with my HB pencil, then soaked the paper with my sponge and prepared plenty of watery paint in my palette.

I used the same colour mixes for the flowers through all five stages. These were: for the yellow chrysanthemum, Cadmium Yellow Pale (not quite pure – I added just a touch of Crimson Alizarin); for the red and orange flowers, Crimson Alizarin and a touch of Cadmium Yellow Pale; for the shadow of the white flowers, Coeruleum and Crimson Alizarin.

First I painted the yellow flower in the centre using my large, round brush, then I did the top yellow flower, the two left-hand ones, the shadow areas of the white flowers and, finally the orange and red ones. The colours ran and merged but this was intentional because I was using a wet-on-wet technique.

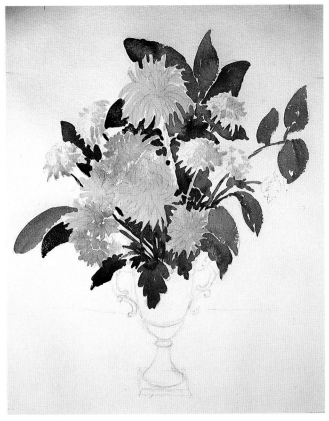

▲ *Second stage*

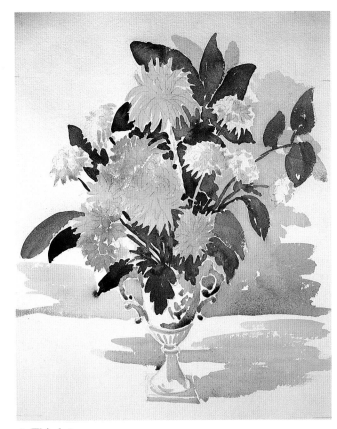

▲ *Third stage*

SECOND STAGE

When this was dry, I mixed watery paint to paint the leaves and stems, using Hooker's Green No. 1, Payne's Grey and Crimson Alizarin. When you draw leaves with your brush, some will run into each other.

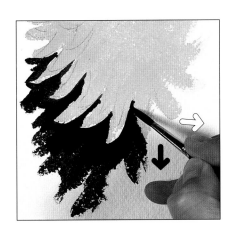

▲ *I worked freely into the flowers when painting the leaves. Notice how the petals look brighter against the dark background (light against dark).*

Again, this is acceptable. Vary the density and colour of leaves as you work. This helps to give light and shade to dark areas.

THIRD STAGE

I painted the vase with a loaded brush and a mix of French Ultramarine, Crimson Alizarin and Yellow Ochre for the handles and moulding. (In this stage, you can see how the wet paint formed a long natural blob at the base of the right-hand handle.)

I added more Yellow Ochre to the same mix for the background and worked very wet from the top downwards. Then I went over some of the leaves to give them a little more depth and variation. You can now see the shapes of the white flowers on the right. Next, I put in the shadows cast by the vase on the base, using the same colours that I used for the background.

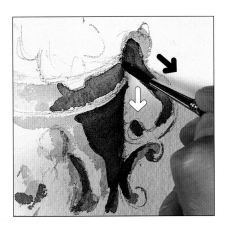

▲ *I used my No. 6 brush to add darker shadows on the vase.*

FOURTH STAGE

Now I worked over the flowers, adding more colour and form. I used the same flower colours but with more pigment, keeping the colour watery but making it very much stronger.

I used my No. 6 brush to draw the petals on the flowers, letting the brush strokes form the petals. Where I wanted a little more dark on the red flower, I added a little French Ultramarine. Remember to keep the colour of the paint strong, your brush wet and your brush strokes free – don't get involved with detail.

FINISHED STAGE

Keeping my No. 6 brush very wet, I painted over the inner leaves and main stem, working the dark colour between the petal shapes to give the final accent (light against dark). You will notice that the two white blooms, top right, appear to be much whiter. This is a typical example of the light against dark principle. Also, the leaf overhanging the vase is more pronounced now that it has been painted again. I added some more dark washes to the vase to give more definition and to help pull it off the background.

With this watercolour technique, if you go too far or put in too much detail at this stage, your picture will lose its charm and freshness.

You will find that certain watercolour techniques can only be executed well when the artist is in key with that particular technique. If you are feeling on top of the world and uninhibited, then this flower exercise, or the landscape on page 44, are the very paintings to work on. However, if you are feeling cosy,

secure and mellow, then you will execute the detailed work in, say, the still life on page 34, or the pencil and wash drawing on page 48, very much better.

Painting comes from your mind, through your arm and hand, into your brush. If you choose the right technique at the right time, you will get the best from yourself.

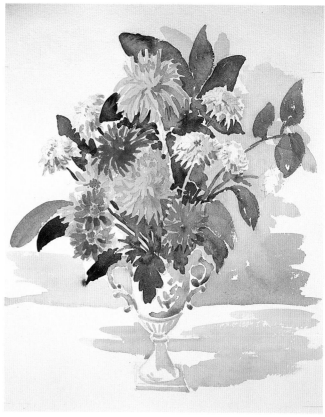

▲ *Fourth stage*

Tips

● Flowers wilt very quickly and can even change their position in a vase. Therefore, any flower that you use as a subject must be capable of outlasting your painting time.

● If you don't manage to finish in time, change the flowers for fresh ones – your painting should have progressed far enough for you to improvise.

▶ *Finished stage*
Flowers
Watercolour paper, 200 lb Not
44 × 33 cm (17½ × 13 in)

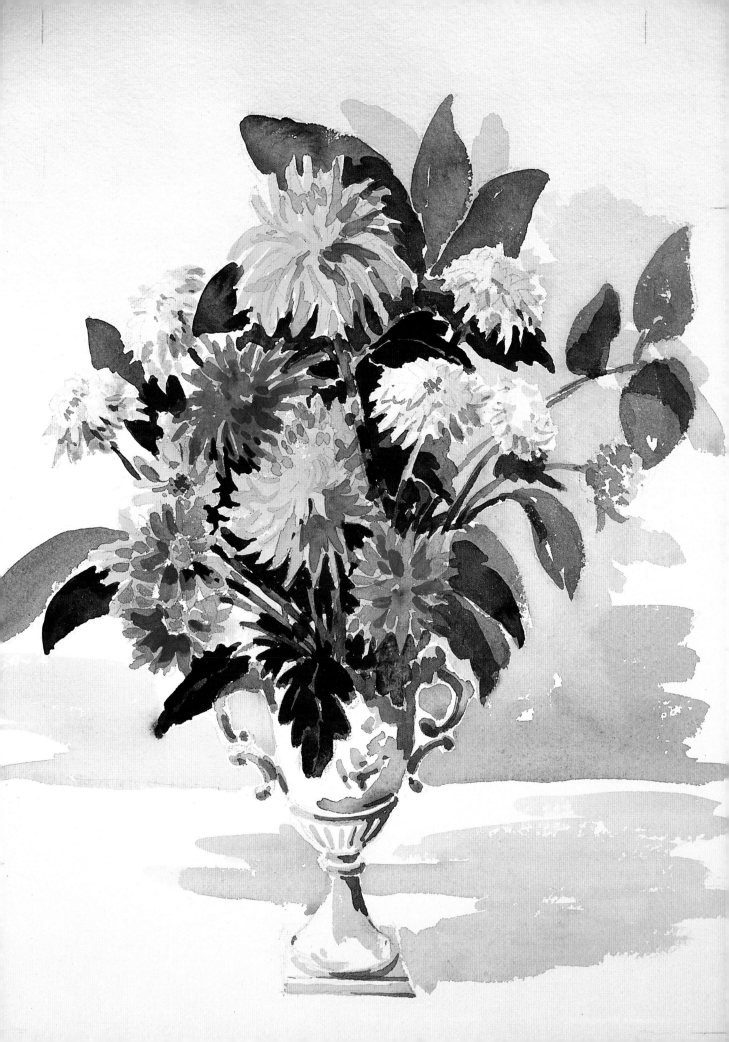

HORSES
DEMONSTRATION

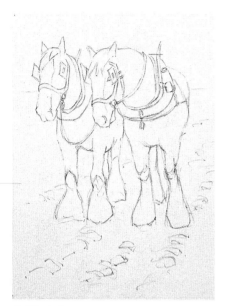

▲ *First stage*

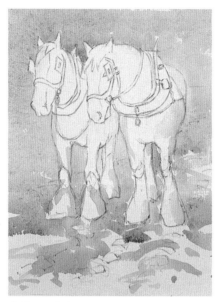

▲ *Second stage*

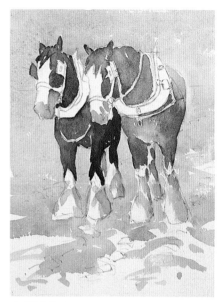

▲ *Third stage*

When you are painting fruit or flowers your subject stays still while you work. With animals it can be just the opposite. Although I have painted working horses in a standing position for up to an hour without them getting restless and moving, I have also had them move away from me after three minutes!

COLOURS
French Ultramarine; Crimson Alizarin; Yellow Ochre; Cadmium Red; Cadmium Yellow Pale.

FIRST STAGE
I drew the horses with 2B pencil. If I had sketched them from life there would have been a lot more pencil lines on my drawing and this would have given it more movement. But I drew them from a sketch and had time

to work more carefully in my studio. The 'life' would be achieved by the painting.

SECOND STAGE
I used my No. 10 brush to paint the background with a mix of French Ultramarine and a little Crimson Alizarin. I painted down from the top, adding Yellow Ochre and a little French Ultramarine and Crimson Alizarin as I reached the ground area. Some paper was left unpainted. I went over the drawing and on to the horses in places. This subtly stops them looking as if they are cut out of the background.

THIRD STAGE
I painted the left-hand horse with the same brush, starting at the top with a mix of French Ultramarine, Crimson Alizarin

and a touch of Yellow Ochre, and worked down. I added Cadmium Red to paint the nose and more Yellow Ochre and Crimson Alizarin as I worked down the body, adding more French Ultramarine to paint the right-hand side of the horse. The harness was left unpainted, except for the horse's right-hand blinker. All this was done while the paint was wet, allowing it to run together.

I painted the second horse in the same way, mixing Yellow Ochre and Crimson Alizarin to work down into the legs. A more watery mix under the chest made this lighter. It will be impossible to copy my horses exactly; your paint will merge differently. Don't worry when this happens – I couldn't paint them exactly the same again.

FINISHED STAGE

Next, I painted Cadmium Yellow Pale on the brass parts of the harness with my No. 6 brush. When this was dry, I painted in the leather of the harness with a mix of French Ultramarine, Crimson Alizarin and a touch of Yellow Ochre. I started at the top of the collar with a weak wash, making the lower part of it darker as I worked down. I went over the edge on to the horse in places to give dimension by suggesting a shadow.

I painted an eye on the right-hand horse and the horses' nostrils, the shadows under their noses, and a small dark shape on the right-hand horse for its bottom lip.

The manes were put in with downward brush strokes and I painted these with the same colours that I used for the horses' bodies.

Next, with a mix of French Ultramarine, Crimson Alizarin and a touch of Yellow Ochre, I painted a shadow where the horses touch, continuing it on to the neck of the right-hand horse.

Finally, I added some more work to the ground with my No. 6 brush and free brush strokes – and stopped fiddling!

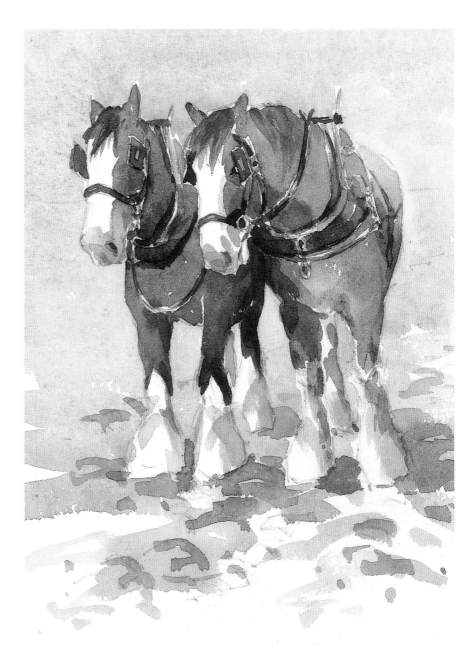

▲ *Finished stage*
Horses
Bockingford 200 lb
26 × 16 cm (8½ × 6½ in)

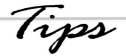

- Sketch horses in pencil to get used to their anatomy before you paint them. I sketch them at ploughing matches, farms, and at the National Shire Horse Centre in Devon.

- Photographs are, of course, a great help, as they keep still! But remember that you must try to work from live horses as well when possible.

▶ *I used my No. 6 brush to paint in the harness, leaving edges unpainted in places to show as highlights.*

43

LANDSCAPE
DEMONSTRATION

For some people, landscape painting holds the promise of an enjoyable day spent in the countryside painting. However, many beginners worry about painting while strangers look on, while others can't get out as often as they would like to.

If you lack confidence, the best way to start is to tuck yourself away behind a tree, make a quick drawing in your sketchbook of a scene you would like to paint, marking the main colours in pencil, then paint it at home. As your confidence grows, take your watercolour box with you – nine out of ten people who take the trouble to look over your shoulder will be full of admiration for you and your work.

Sketching in pencil is also a good idea for the person who can't often get outside. Instead of painting just one scene when you do go out, make a few different pencil sketches. Take your paint box and some water with you, and make colour notes on these sketches. You can use this information to produce many different paintings later at home.

I have chosen this landscape for working the wet-on-wet technique. This gives a really wet watercolour look. I love using this technique, especially when worked to the extreme as it is here. It has an element of risk (where is the paint going?) and one of great excitement. Although you have planned in your mind what you want to do and you can

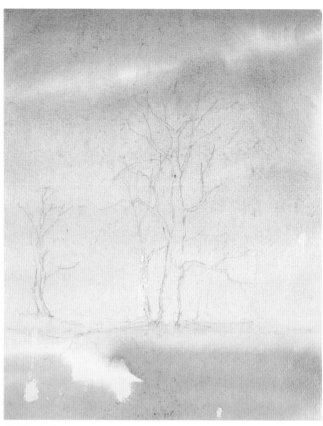

▲ *First stage*

control it to a great extent, there is the certainty of many a happy accident, and even pure surprise.

For you to copy this picture, or for me to copy it and achieve the same result, would be impossible. Just work towards the same composition and, if a happy accident occurs, take advantage of it. Your painting will then have its own little gems created by this technique.

Remember to thoroughly soak your paper and note that, once you start a painting like this, you are committed to continue to the end while it is still wet or damp!

COLOURS
French Ultramarine; Crimson Alizarin, Payne's Grey; Yellow Ochre; Burnt Umber; Hooker's Green No. 1.

FIRST STAGE
I drew the picture with my HB pencil, using a minimum of drawing, then soaked the paper with water using my large brush.

Now to starting the painting. I put French Ultramarine, Crimson Alizarin, Payne's Grey and Yellow Ochre on to my palette but didn't mix the colours together. Instead I applied them

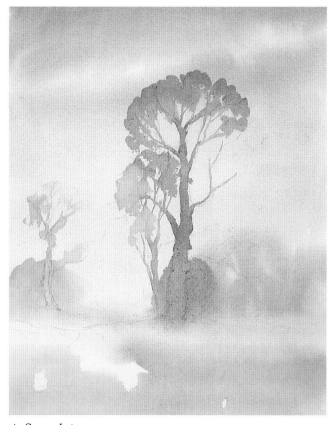

▲ *Second stage*

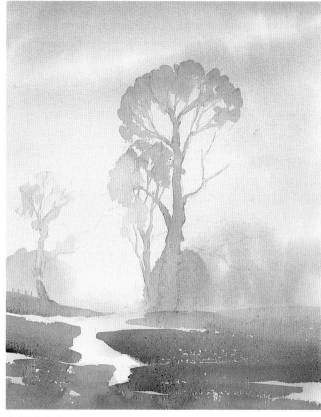

▲ *Third stage*

to the wet paper so that they mixed on the surface to create beautiful effects – notice how the sky ran into the land. I left an unpainted area for the puddle.

SECOND STAGE

Using a wash of Payne's Grey, Crimson Alizarin and Yellow Ochre, I then painted the middle-distance trees using my large brush.

These ran into the sky and lost a bit of shape but it didn't matter since I was creating the impression of a landscape in early-morning mist.

While the middle-distance trees were wet, I painted the main trees into them. Then, using my No. 6 brush, I added some smaller branches.

Next, I took my large brush on to the now damp sky and dragged the brush down into the wet, small branches (so

that they all ran together) to form the top of the trees.

If at any stage you find that your work dries out too quickly for you, simply wet the paper again. This may move some of the pigment, but if you are careful to do it gently, you will get away with it.

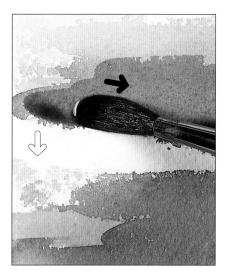

THIRD STAGE

Using my large brush and plenty of watery paint (Payne's Grey, Burnt Umber, Hooker's Green No. 1 and Crimson Alizarin), I painted the foreground. You will notice that the puddle is more obvious now that a darker tone has been added.

◀ *I used plenty of watery paint for the foreground. Remember, you won't be able to copy me exactly when you do this – let your paint find its own way.*

45

FOURTH STAGE

I worked over the main tree again while it was still damp. I used my No. 6 brush to put in some more branches but kept them light in tone at the top. I also painted the tree in the left-middle distance and added the little bit of fence to the right of the main tree.

FINISHED STAGE

I put another wash of darker colour over the foreground and added any darker accents I felt were necessary for the picture. Don't overdo the detail when you are using this technique. To give you some idea of timing on this type of picture, I took about 45 minutes to complete it.

This effect cannot be achieved if you work slowly; the very essence of the technique is speed. Some artists use this technique to start a painting and then, when it has reached the final stage they spend a lot of time working it up into a highly detailed watercolour – you could try that next time.

● A landscape can be painted from a window, if necessary, but you must sketch and paint outside as much as possible.

● Always carry a sketchbook with you; even if you only have ten minutes to sketch a scene and draw only ten lines, you will have had to observe it.

● With plenty of practice, you will find that, in time, you will be capable of painting indoors from memory.

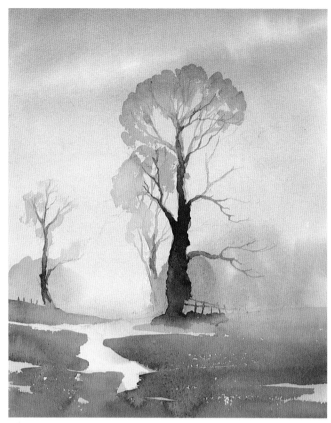

▲ *Fourth stage*

▲ *When you are doing this type of painting, always remember to keep detail to a minimum.*

▶ *Finished stage.* Landscape *Watercolour paper, 200 lb Not 37 × 28 cm (14½ × 11 in)*

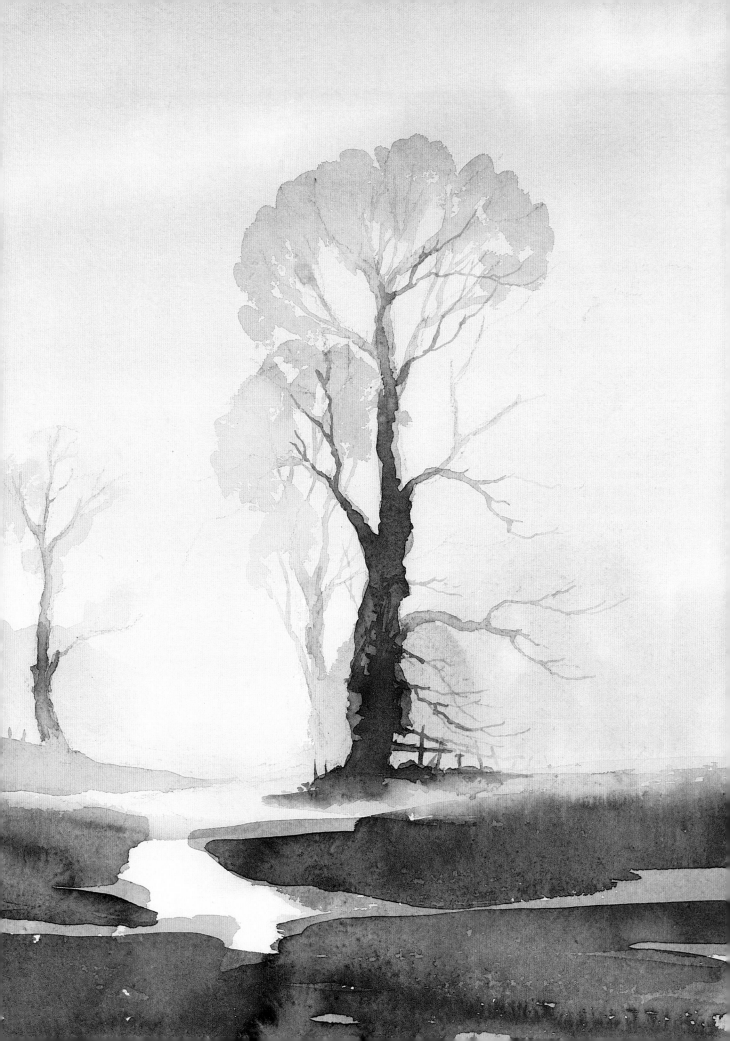

BUILDINGS

Demonstration

Buildings can be a tremendous source of pleasure to the artist. You may be inspired by the size and splendour of a building or by the quaint, olde-worlde charm of a village street.

Watercolour is a useful medium for painting buildings, and buildings are a good subject for the student of watercolour. When you look at buildings with painting in mind, you will see that the colour areas are broken up into the different shapes of roofs, walls, windows, doors, and so on, which are all quite well defined and give you the areas on which to work your washes. But these should be disciplined washes and different to those you used for sky exercises on page 33.

The subject of this exercise, I believe, is not too advanced and I have made it a pencil and wash drawing for those who can draw. I find cartridge paper ideal for this type of work. It is excellent to draw on and takes washes very well. Working this size, you will find your paper stays reasonably flat when you apply washes.

COLOURS
French Ultramarine; Crimson Alizarin; Cadmium Yellow Pale; Cadmium Red; Yellow Ochre.

FIRST STAGE
Using my 2B pencil, I started by drawing a horizontal line for the distant water. This was my eye level. Next, I drew vertical lines

▲ *First stage*

for the main buildings and then the tops of the buildings. Remember the boxes you drew for the perspective exercise on page 19? Well, buildings are drawn in just the same way. All the parallel lines – windows, balconies, doors, etc. – converge at a vanishing point at the eye level. Look at the boxes again and see how this works. Use a ruler to establish some important lines if you wish; with experience, you will 'see' and draw perspective as second nature. Next, I drew in the bridge and boats.

● When painting buildings outside in watercolour, you need only a small amount of basic equipment to achieve success: a stool, sketchbook or paper on a drawing board, paintbox, brushes, water container, pencil and eraser.

● Remember, you can often get a very good view from a public bench if you don't want to be weighed down with a stool!

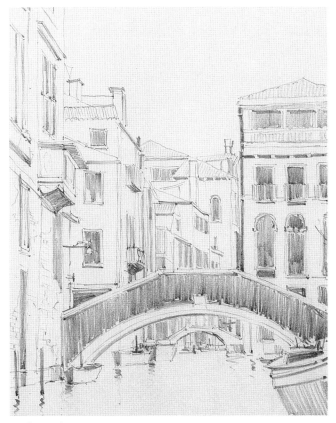

▲ *Second stage*

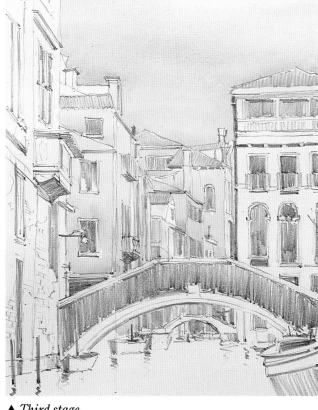

▲ *Third stage*

SECOND STAGE

Once I had established the main shapes of the drawing, I added detail and shading. The light source was coming from the right. Always be free with your pencil lines or your picture will look too much like an architectural drawing.

▲ *I shaded the bridge with vertical pencil strokes, letting them join in places and miss in others.*

THIRD STAGE

I used my No. 10 brush and a mix of French Ultramarine and a little Crimson Alizarin to paint the sky, then painted the roofs with a wash of Cadmium Yellow Pale and Cadmium Red.

Next, I painted delicate washes over the middle-distance buildings, starting from the left-hand one with a mix of Crimson Alizarin and a touch of Cadmium Yellow Pale. I used Yellow Ochre and a touch of the first building colour for the second one, and the roof colour for the third.

The other building colours were made from a variation of the first ones, except the last one on the right, which was pure Cadmium Yellow Pale. As I painted these washes over the shading and pencil lines, my pencil showed through. This retains the structure and adds tone to the buildings.

FOURTH STAGE

I did all this stage with my No. 10 brush and started with the left-hand building. The pink colour at the top right of it was mixed from Crimson Alizarin and a touch of Cadmium Yellow Pale. I worked this over all the building, leaving some areas unpainted and painting others with Yellow Ochre. The red colour represents bricks and the unpainted and Yellow Ochre areas, broken plaster. I painted the brick colour in places with broken brush strokes in perspective (to give the impression of bricks).

Then, using a mix of Yellow Ochre and a touch of Crimson Alizarin, I painted the right-hand building, starting at the top and working downwards. I painted over the windows with a mix of French Ultramarine and Crimson Alizarin. If you find that paint doesn't take easily on shaded pencil at first, scrub the brush over it a few times until it does.

I used a mix of French Ultramarine, Crimson Alizarin and a touch of Yellow Ochre to paint over the front of the bridge in the foreground and then the one behind it. Then, with a wash of French Ultramarine and a little Crimson Alizarin, I painted over the left-hand building and the white edges of the bridge. This immediately gave the illusion of shadow and leaving the top right of the building unpainted gave the impression of sunlight.

FINISHED STAGE

I used my No. 6 brush and the same shadow colour, but more watered down (paler), to paint in the shadows on the middle-distance houses. Then, with the same colour, but darker, I painted in the windows and doors on the left-hand building.

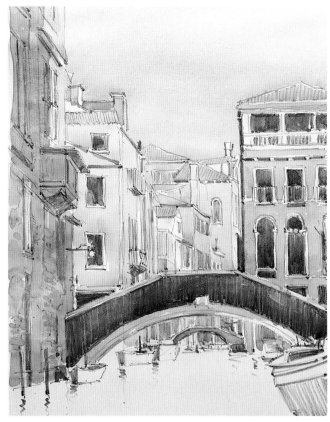

▲ *Fourth stage*

I painted the two boats with pale French Ultramarine, using a slightly stronger colour for the one in the foreground. Still with my No. 6 brush, I painted in the water using the colours of the buildings and boats and working in broken horizontal brush strokes to give the impression of sunlight on water.

Finally, I added dark accents where I felt they were necessary.

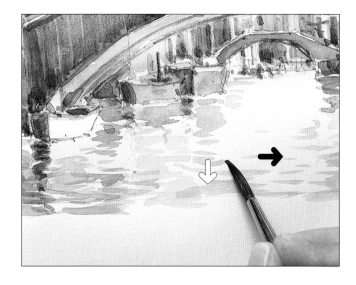

▲ *The reflections were painted freely. I left some white paper unpainted to show sunlight on the water.*

▶ *Finished stage.* Venice
Cartridge paper
29 × 23 cm (11½ × 9 in)

50

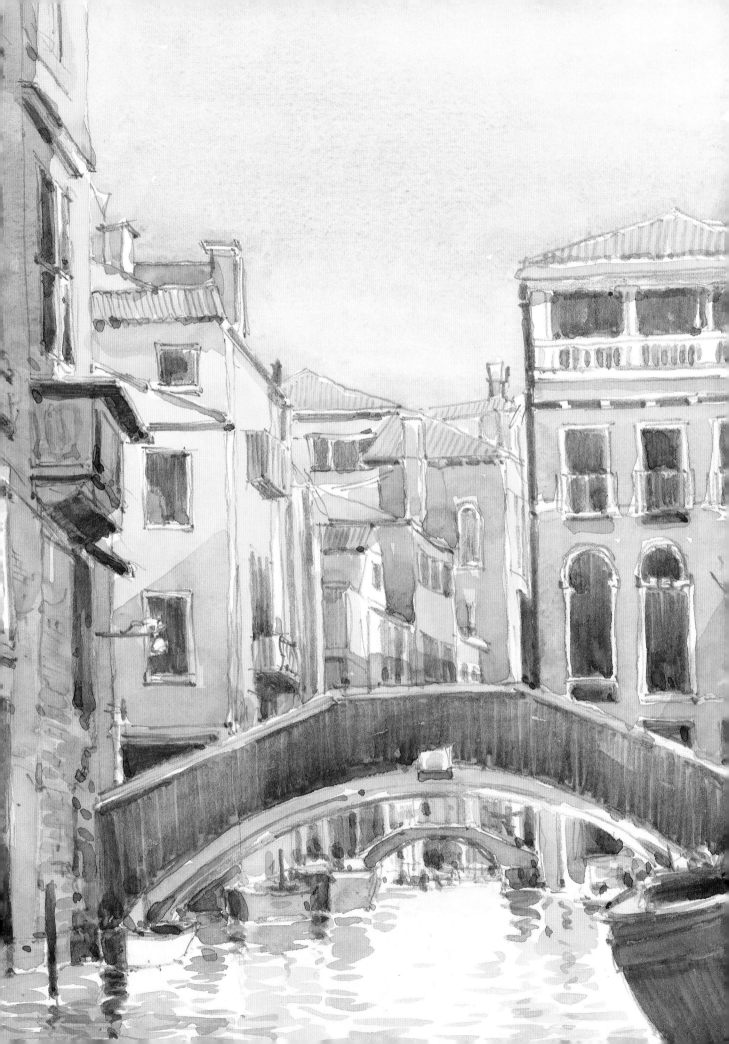

WATER
DEMONSTRATION

▲ *First stage*

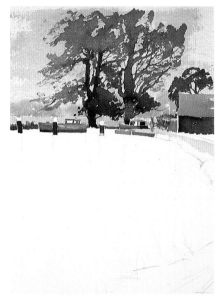

▲ *Second stage*

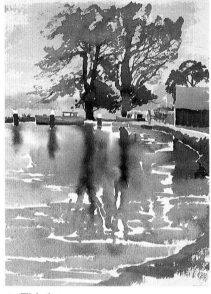

▲ *Third stage*

A lake or a pond (unless discoloured by mud) reflects its immediate surroundings and the sky. In very clear, still water, the reflection of a building is a mirror image of itself and so you will be painting this image upside down in the water. Remember, when you put in the reflection, it will go down vertically into the water, not across the surface.

It is only the movement of the water that shows us horizontal lines, and you must always remember that any movement breaks up the reflected images. Light on moving water is also seen horizontally.

So, the first golden rule for painting water is to make sure that all movement lines or shapes are perfectly horizontal. Learn to observe the different moods of water and remember that a

reflection immediately creates the illusion of water.

COLOURS
Coeruleum; Crimson Alizarin; French Ultramarine; Hooker's Green No. 1; Cadmium Yellow Pale; Cadmium Red; Payne's Grey; Burnt Umber.

FIRST STAGE
I drew the picture with my HB pencil but didn't draw on the water area; these shapes would be created with my brush. A very wet-on-wet technique is usually ideal for portraying water. However, before I started any work on this, the surroundings needed to be painted first as these would determine the colour and the shapes on the water.

I wet the paper with a sponge, then painted a wash of Coeruleum

and Crimson Alizarin. Just before this was dry, I put in the middle-distance trees with French Ultramarine, Crimson Alizarin and Hooker's Green No. 1. I used Cadmium Yellow Pale and a little Crimson Alizarin for the field below them, then painted the roof of the boathouse with Cadmium Red, Cadmium Yellow Pale and Hooker's Green No. 1.

SECOND STAGE
I used a mix of Payne's Grey and Hooker's Green No. 1 for the mooring posts and the side of the boathouse, then painted the tree trunks adding Payne's Grey to the mix and working upwards with my large brush.

While the trunks were still wet, I painted into them with Cadmium Yellow Pale, Hooker's Green No. 1 and Crimson

Alizarin. I used my No. 6 brush and diagonal strokes from right to left at a flattish angle to the paper. These broad, hit-and-miss strokes created the impression of leaves. Then I painted the boats and the bank of the river.

THIRD STAGE

I damped the paper again over the water area and, while it was still wet, ran in the reflected colours. Before doing this, I decided roughly where the tree trunks, the red of the roof, etc., were going to be. I often have a dummy run over the paper with my brush to get the feel of where the strokes and colours will go.

As you can see, the colours merge and the water could be finished at this stage. Although this was only the first wash, it already has the appearance of water because the colours run into each other and the reflections and colour complement the background.

FINISHED STAGE

When the first wash was nearly dry, I added darker washes and definite reflection shapes to give more detail to the water and then scratched out some horizontal highlights with a blade.

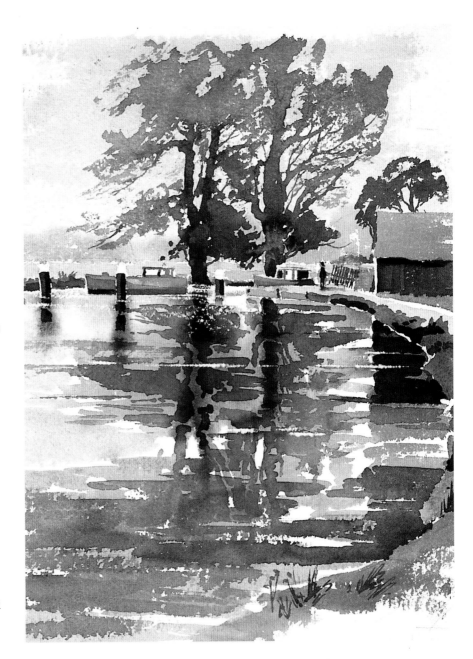

▲ *Finished stage*
The River Wey, Surrey
Watercolour paper, 200 lb Rough
28 × 21 cm (11 × 8¼ in)

- Painting reflections can be approached in the same way as painting glass (see page 32).

- Always observe your subject carefully and decide what the main shapes and colours are.

- Leaving white paper to suggest water can be very effective (see the lake in sky exercise **d** on page 33).

▶ *I applied these final washes very freely. Remember, once washes have been painted, don't fiddle with them!*

SNOW
DEMONSTRATION

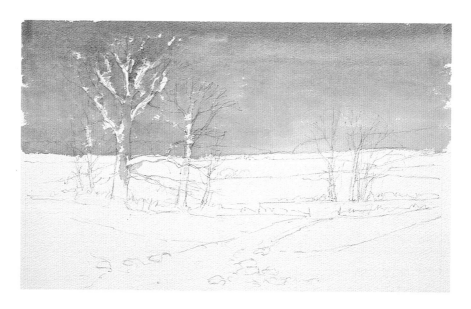

▲ *First stage*

Snow has a fascination all of its own: the stillness of a snowy landscape can be unbelievable; with trees standing out in sharp silhouette. When painting snow with watercolour, leave as much white paper as possible. Snow is only white in its purest form (even then, it reflects light and colour from all around) but you need white paper on which to add tone and colour reflections as you build up the painting.

Add a little blue to cool the snow colour, or a little red or yellow to warm it up. Don't be afraid to make snow dark in shadow areas. Compared to its surroundings, it can be as dark as a shadow in a landscape without snow.

COLOURS
French Ultramarine; Crimson Alizarin; Yellow Ochre; Hooker's Green No. 1; Cadmium Yellow Pale.

FIRST STAGE
I drew the picture with my 2B pencil. I didn't try to draw every branch on the trees – the object was to get the overall shape. The small branches would be done at a later stage with my brush.

Using my No. 10 brush and French Ultramarine, Crimson Alizarin and Yellow Ochre, I painted down the sky, adding more Yellow Ochre as I got closer to the horizon. I added more water to my wash to make the sky paler when I reached the gap in the distant trees.

Then I painted over the main tree trunk in places and also around some of the branches on the left-hand trees, but very freely. Some of these areas of unpainted white paper would be left showing when the painting was finished. This helps to give life to the trees and suggest snow on branches.

SECOND STAGE

When the sky was dry, I put in the distant hills with my No. 6 brush and the sky colour wash, adding more French Ultramarine to make it bluer. I left some areas unpainted to suggest branches for the trees in the middle distance.

I used the same colour to paint the hedges and to suggest fields. When this was dry, I put in the group of middle-distance trees, using my 'Rigger' brush and the sky colour, but with a little more Yellow Ochre added to the mix. By mixing plenty of colour for the sky, all I needed to do was to keep adding to it to change the colour as I worked. This was because, in the painting, most of the colours were either cool or warm greys.

I painted these trees starting with the main trunks and putting pressure on my brush to get a wider brush stroke for the main trunks, then took the pressure off and used the point of the brush to work upwards to make thin lines for the thinner branches. I put in the hedges with my No. 6 brush.

THIRD STAGE

Next, I painted the main group of trees. I used my No. 6 brush for the main trunks and thick branches, and changed to my 'Rigger' brush for smaller branches. I worked from the bottom of the trunk upwards in the direction the tree grows, remembering to leave some unpainted paper at the bottom of the trunk to represent snow.

I mixed Hooker's Green No. 1 and Cadmium Yellow Pale for the bottom of the large tree and worked upwards, adding French Ultramarine, Yellow Ochre and a little Crimson

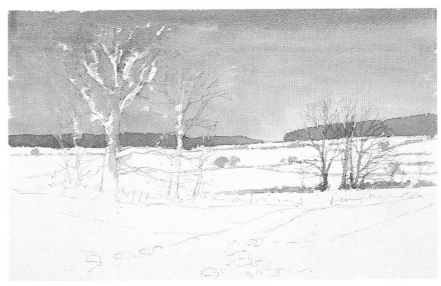

▲ *Second stage*

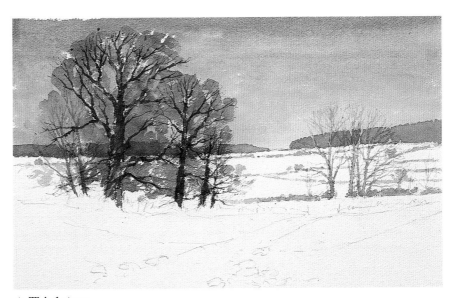

▲ *Third stage*

Alizarin. I mixed Yellow Ochre and Crimson Alizarin to make a warmer colour for the two small trees to the left, and then used a light green for the two small trees on the far right.

When this was dry, I painted the feathery branches (the overall tonal shape of the tree) with my No. 10 brush. I used the tree colours, but added more Yellow Ochre and Crimson Alizarin to suggest autumn colours in the middle of the group, making the paint watery. I applied it freely, letting the colours run together.

Tips

● If you go outdoors to paint snow, make sure you wear plenty of warm clothing. You can always discard some layers but you can't necessarily go home for more!

● It is also a very good idea to carry your sketchbook in a polythene bag so that it will stay dry if it is dropped in the snow. I once dropped mine (unprotected) in a pond!

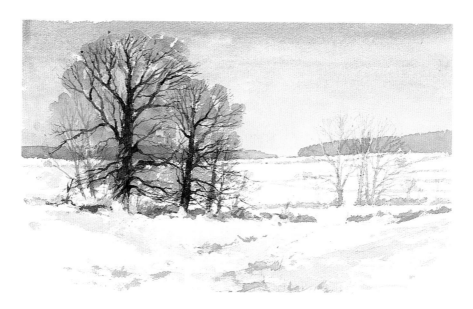

FOURTH STAGE

I then painted in the hedge under the main trees with my No. 6 brush. I used a variation of my tree colours for this but I left the bottom edge of the hedge rough to suggest drifted snow. I worked from the left and continued to the open gate, then worked to the right of it.

When this was dry, I went over the hedge in places to add some darker areas. Then, with the same colours, I painted the uncovered patches of earth and grass.

I worked over the main trees again to make them darker but left some of the first wash showing because this helps to suggest sunlight.

Then I mixed a wash of French Ultramarine and Crimson Alizarin and painted it on the field to represent shadows of the trees on the snow. When you do this, use your No. 10 brush and make sure the patches of earth colours are completely dry, or the shadow colour will merge with the wet earth colour.

▲ *Fourth stage*

▼ *Drag the brush downwards to suggest feathery branches.*

▶ *Detail (actual size)*

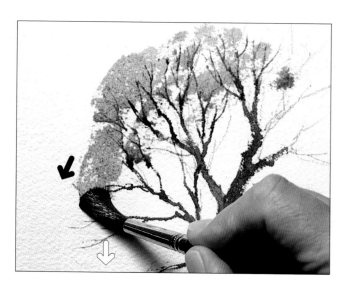

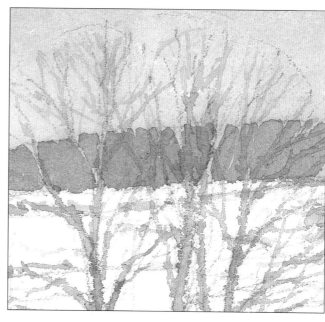

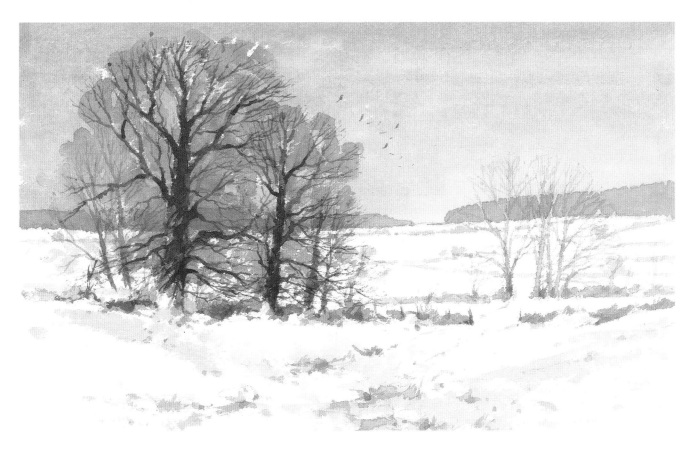

FINISHED STAGE

The only problem I had now was to stop myself from fiddling and overworking the painting!

I added more work to the main trees and hedge, making the left-hand tree in the middle distance darker at the bottom, and the hedge darker to the right of the right-hand tree. This makes that tree look lighter.

Then I put in the gate posts and added some darker tones to the foreground snow to give it dimension, finally, painting in the birds with my No. 6 brush.

▲ *Finished stage*
Snow scene
Whatman 200 lb Rough
28 × 44 cm (11 × 17½ in)

◄ *Detail*
(actual size)

▼ *Use the point of the 'Rigger' brush to paint thin branches.*

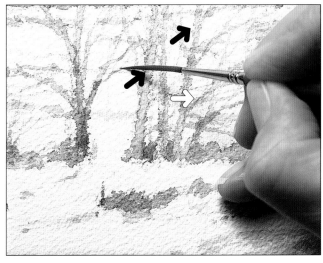

HARBOUR
DEMONSTRATION

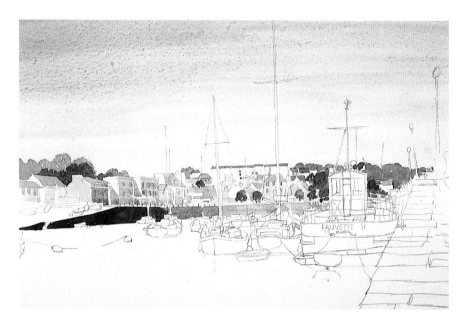

▲ *First stage*

Usually, artists who like painting the sea also enjoy painting harbours and boats. A busy harbour scene with boats bobbing around can create a wonderful feeling of activity, especially with the sun dancing on the boats and the water.

You need more knowledge of drawing to paint boats than to paint a landscape. If you paint a branch of a tree lower than the real one, it will still look correct in your painting. However, if you paint the mast of a boat at the wrong angle, then your painting will look very obviously wrong.

This harbour scene was taken from a sketch and I had plenty of time to correct the drawing and to make a careful study on paper in my studio. If I had painted it outside, my drawing would have been looser and the painting would have been much more impressionistic. Because of all the activity and the amount of drawing needed in the harbour, I decided to do this picture with a pen and wash technique and used bold colours to portray a very sunny, summer afternoon.

COLOURS
Coeruleum; Crimson Alizarin; French Ultramarine; Cadmium Yellow Pale; Hooker's Green No. 1; Yellow Ochre.

FIRST STAGE
I used my HB pencil to draw the picture, making sure that the edge at the bottom of the harbour wall (i.e. the water level) was horizontal.

Then I used my large brush to paint a wash of Coeruleum and Crimson Alizarin on to the sky, adding more Crimson Alizarin and water as I neared the

Tips

● You will acquire a great deal of knowledge as you become more and more familiar with boats and their surroundings.

● If possible, spend a few days sketching all the bric-a-brac, (natural and unnatural) around a small harbour – from an old wreck sticking out of the mud like the backbone of a great fish, to an old piece of chain, rusty and abandoned.

rooftops. I painted these with my No. 6 brush and a wash of French Ultramarine and Crimson Alizarin, adding Cadmium Yellow Pale to the wash to paint the buildings. I let some of this colour mix (the darker tones) work as shadows on the buildings, and added some Hooker's Green No. 1 to this colour to paint in the trees.

Finally, adding more French Ultramarine to the same wash, I painted the near side of the harbour wall, watering down the wash for the distant part.

SECOND STAGE

Starting from the left-hand side of the picture, I finished painting both the houses and the little boats with my No. 6 brush. I used darker tones to suggest windows with single brush strokes. With a pen and wash technique, you don't need to be too neat with your washes because, when you start drawing with your pen, the ink strokes will clean things up and hold the picture together.

As I worked to the right of the houses, I made sure I put in the distinct shadows on the two square white buildings. Then I let my brush wander along the quay and distant houses, making shapes and suggesting buildings.

I painted the middle-distance boats, using a mix of French Ultramarine and Crimson Alizarin for the shadow areas on the white boats. I worked these boats freely without too much detail – again, this would be put in later with my pen. I was really just putting in shape and form, expressed by colour and tone (light and shade).

When painting the woodwork on the boats, I used Cadmium Yellow Pale, Crimson Alizarin and a touch of French Ultramarine, working from the distant boats to the nearest ones.

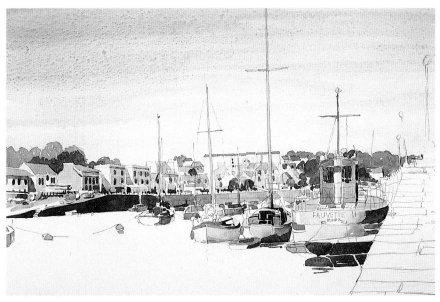

▲ *Second stage*

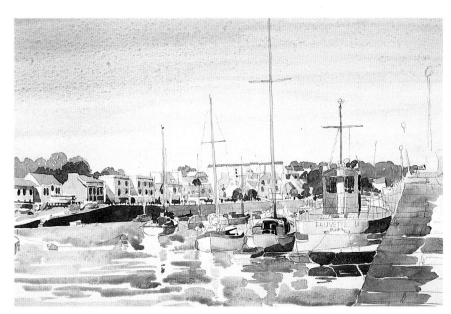

▲ *Third stage*

THIRD STAGE

Now I was ready to paint the water. In the water exercise on page 52, I worked on wet paper. For this demonstration, I didn't wet the paper first.

I used my large brush to mix a wash of Coeruleum and a little Crimson Alizarin (to reflect the sky colour) and still had the local colours of the boats on my palette. I started at the harbour wall and worked down the painting, leaving plenty of white paper showing. I worked the brush freely, in horizontal strokes, adding my boat-coloured reflections as I came to them. If any paint ran into another part of the water, I let it. This helps to give more feeling to the area.

Then I painted the flat stone on the edge of the harbour wall with French Ultramarine, Crimson Alizarin and Yellow Ochre, using my large brush and keeping the strokes horizontal.

▶ *Fourth stage*

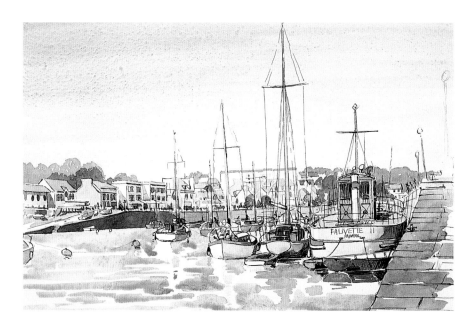

FOURTH STAGE

I used black Indian waterproof ink for the pen work. This can be applied with different types of pen and various treatments.

You can use a felt-tipped pen with a fine point, a fountain pen with the correct nib or a mapping pen. The advantage of using a mapping pen (as I have) is that you can draw a very fine line. You can't do this with other pens. A disadvantage is that, while you can happily make a stroke up or down the paper with a felt pen, if you try this with a mapping pen and use too much pressure, or the paper has too much tooth, the pen will bite into the paper on the up stroke and splatter your work with ink and even bend your nib. Remember, the downstroke can be heavy but the upstroke must be lighter in pressure. Practise on some paper before going on to a painting – as with your brushes, get used to your pens.

I started on the left of the picture, drawing the houses, windows, shutters, shadows under the eaves, and so on.

When I worked into the distant houses, I used my pen very lightly to make thinner lines because these houses had to stay in the background on the other side of the harbour. Then I worked on the boats furthest away in the harbour, giving them shape. I let the pen doodle a little here and there to give a busy, crowded look in the middle distance. I was just aiming to portray a suggestion of activity in this area.

As I worked forward, towards the nearest boats, I started to put in more detail as I got nearer the quay wall. I then drew in the masts of the larger boats and some rigging. I also suggested some stonework on the harbour wall on the right, making my pen lines stronger there.

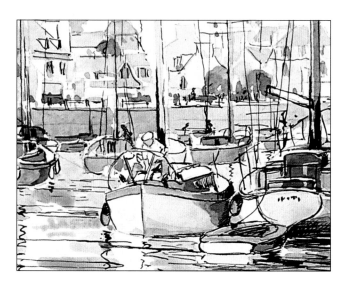

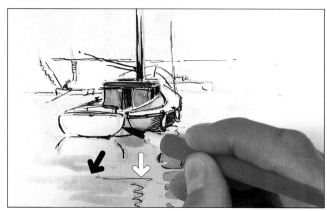

◀ *Detail
(actual size)*

▼ *Upstrokes of the pen must be light but downstrokes can be heavier.*

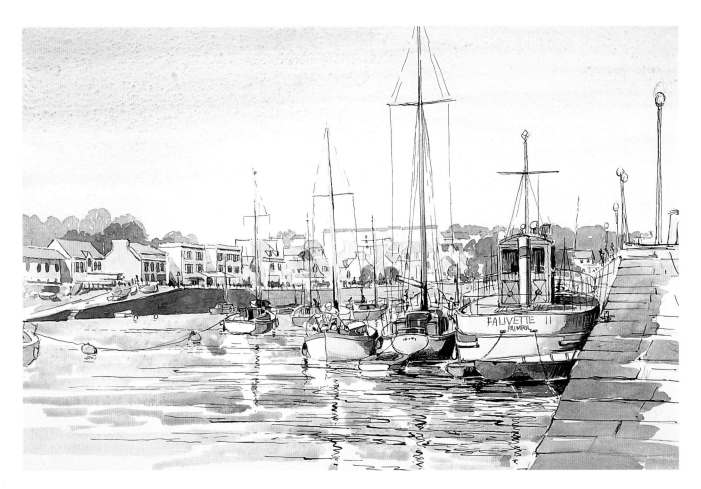

FINISHED STAGE

The water was the last stage. I used my pen at a much flatter angle than for the boats and general work and still left plenty of white paper. In the photograph below you can see the pen is held very low to make horizontal strokes. These strokes are also thicker and looser than the other pen work.

Finally, I added some more accents and an impression of harbour paraphernalia with my pen. If you like (I didn't here), you could add a bit more colour or tone with the paint if you think it will improve your work.

▲ *Finished stage*
A harbour in Britanny
Watercolour paper, 140 lb HP
25 × 37 cm (10 × 14½ in)

▼ *I held the pen flatter to the paper to make thicker horizontal strokes.*

▶ *Detail*
(actual size)

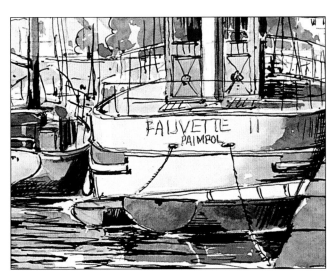

SEASCAPE
DEMONSTRATION

The sea is a fascinating subject with extremes of mood from romantic to quite terrifying! Like the sky, it changes colour and, of course, is always moving.

Your horizon line must always be horizontal, otherwise the sea will appear to be falling off the paper. If necessary, draw it with a ruler. Cliffs, beaches, rocks and boats will add more interest to a landscape. A headland and cliffs give distance and perspective, while beaches and rocks give us the opportunity to paint crashing waves and flying spray.

COLOURS
French Ultramarine; Crimson Alizarin; Yellow Ochre; Hooker's Green No. 1; Cadmium Yellow Pale.

FIRST STAGE
I drew the picture with my 2B pencil, then painted the sky with my No. 10 brush and French Ultramarine, adding Crimson Alizarin nearer the horizon. I left small areas of white paper unpainted in the cliff area.

SECOND STAGE
When this was dry, I put in the distant cliffs and headland with a wash of French Ultramarine and Crimson Alizarin, working from left to right and adding Yellow Ochre and more Crimson Alizarin as I painted.

I continued using my No. 10 brush to paint the sea with a colour mix of French

▲ *First stage*

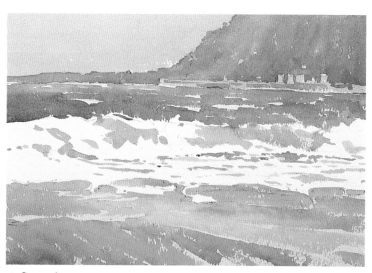

▲ *Second stage*

Ultramarine, Crimson Alizarin and Hooker's Green No. 1.

I started at the top and worked down to the wave that is breaking on the beach, but I left long shapes unpainted to represent other breaking waves. Then, with French Ultramarine and Crimson Alizarin, I put in the shadows on the main breaking wave and the foam running up the beach. I added a little Hooker's Green No. 1 to the right-hand side of the wave and into the foam.

I painted the beach with free brush strokes, using Yellow Ochre, Crimson Alizarin and French Ultramarine.

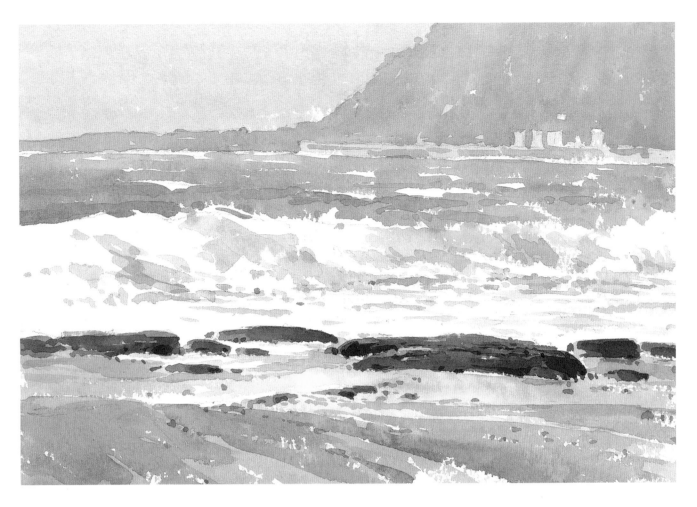

FINISHED STAGE

I used my No. 6 brush to paint in the rocks with a mix of Hooker's Green No. 1 and Cadmium Yellow Pale for the light areas and French Ultramarine, Crimson Alizarin and Yellow Ochre for the dark ones. I let the brush strokes go in the direction of the formation of the rocks.

Then I painted over the foreground of the beach with my No. 10 brush and a wash of French Ultramarine, Crimson Alizarin and a touch of Yellow Ochre. I painted the rocks darker and worked over the sea again in some places with the same sea colour as before, but lighter. This helped to give movement. I also put in some more shadow work on the breaking wave.

Finally, I put in some pebbles on the beach.

Tips

● Whenever possible, try to observe the sea from life. Sit on the beach and watch wave after wave coming in to learn how they are formed and how they break.

● Then try sketching the sea with a 2B pencil, concentrating on the shape and form of waves.

● A wave breaks very quickly but if you continue drawing successive ones, you will find that these break in approximately the same place.

▲ *Finished stage.* Seascape
Waterford 300 lb
25 × 38 cm (10 × 15 in)

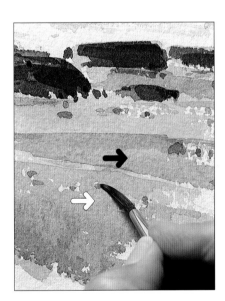

▲ *I added dark shadows to small light areas on the beach to give the illusion of pebbles.*

POINTS TO REMEMBER

● Plan your watercolour carefully before you start.

● Always keep your brush fully loaded with watery paint when you are working on a wash.

● Wait for one wash to dry before applying another, unless you are using a wet-on-wet technique.

● Use white paint only for body colour painting.

● Clean white paint off your palette when you have finished with it.

● Always keep your colours in the same position in your watercolour box.

● When using watercolour, always work from light to dark.

● Try not to overwork your painting – don't fiddle!

● After experimenting, select one paper and stick to it.

● Remember, observation is the key to good painting.

● Use the best quality brushes you can afford.

● Keep practising – success can be just around the corner!